LOOSE CHIPPINGS

or

THE UNKNOWN COTSWOLDS

GW00320012

LOOSE CHIPPINGS

or

THE UNKNOWN COTSWOLDS

by

NIBOR RAHEB

Bene Factum Publishing
PO Box 58122
10 Elm Quay Court
Nine Elms Lane
London
SW8 5WZ

This edition published by Bene Factum

A copy of the British Library Cataloguing in Publication
Data is available from the British Library.

ISBN: 978-1-90307161-8

Illustrations: Sebastian Roberts
Cover design: Mousemat Design Ltd
Book design and typesetting: Prue Fox
Printed and bound: ImprintDigital, UK

DEDICATION

This book is dedicated to **M**, without whom the Author would never have discovered the Cotswolds or been inspired by its extraordinary inhabitants.

AUTHOR'S NOTE

No characters recorded in this book are intended to represent or bear any similarity to any living persons known or unknown to the author; and while he would have much enjoyed knowing many if not all of them, the existence of such people would be the merest of coincidences for which he can bear no responsibility. All that can be noted is the strange fact that history does on occasion repeat itself, which is why a knowledge of the subject is of such vital importance to every generation if the errors of the past are not to be repeated eternally.

CONTENTS

PREAMBLE

History happens where the wind blows.

Despite our best – or worst – intentions, events have a way of choosing themselves rather than letting us orchestrate them. And when things go badly wrong, we often say "it's an ill wind blowing".

These are tales of the windswept uplands of the Cotswold Escarpment that rises high above the eastern side of the Severn Valley and bears the brunt of the Atlantic Westerlies as they sweep in over Wales and across our beautiful green island. They bring with them glorious cloud formations of every kind that scud or billow or drift across the patchwork of rolling drystone-walled fields and copses, villages and woods, that form an almost unique landscape that attracts visitors from literally the ends of the earth.

Sometimes those winds howl and shriek through the Gloucestershire woods, and people huddle by their firesides glad of their thick stone walls and cosy hearths; othertimes they waft and gently breeze, zephyrs of sweet springtime or summer air, and the shining countryside smiles in the bright sunlight.

Folk here have always caught the mood of the sky and lived by its vagaries, just as they have contended with the capriciousness of their history. They see the winds as their inheritance, that have brought in their wake so many and varied rulers and their armies; and while it is the kings and princes, the great soldiers and the occasionally turbulent priests, whose names are recorded in the annals for all time, it is the folk who inhabited the land, the silent and often unwilling majority in whose name their leaders waged their wars, who made their conquests possible, who suffered their defeats, and who continued simply to exist, unrecorded, as the helpless witnesses to their often terrible times.

But history is not all gloom. It has its gaiety, its

tender moments, its amusements, its secrets, and indeed so many unexplained and inexplicable events that we are left in those most enchanting realms of conjecture that free the imagination and, thereby, the spirit. These are but random excerpts, based on anecdote and hearsay, from that "secret history" in a part of England that is at once ancient, mysterious, steeped in arcane traditions, and quite extraordinarily picturesque and fascinating.

These are the Unknown Cotswolds.

GENERAL BACKGROUND

It does rather seem that the greater part of human history consists of an endless catalogue of battles: of invasions, conquests, occupations, pogroms, resistances, revolutions, counter-revolutions, and the general imposition of will by *force majeure* on the principle of "might is right" whenever and wherever the opportunity arose, which was pretty constantly. It seems that conflict is embedded indelibly in Man's nature, and that all his acts are to a greater or lesser degree adversarial. Indeed this may well explain the absence of visits to this planet from any superior technical civilizations, who may have examined our behaviour over the centuries and concluded we are a deranged species that is better left ring-fenced and quarantined, prevented thus from colonizing and thence contaminating the Universe with our violent tendencies!

For some reason, and surely it can't have been the climate, there was an endless historical line-up of candidates eager to invade England and often there-after to murder or evict its erstwhile inhabitants.

Way back in AD 43 the Romans rowed over from Gaul and started building roads, villas, and towns all the way up to the Scottish border. It took the local Brits, in the form of the legendary Boudicca (Boadicea to anyone educated before about 1970), almost 20 years to cry "enough!" and, in AD 61, to revolt. Fat lot of good it did them, other than inspiring a few rollicking movies almost 2000 years later, but the Scots proved more unmanageable and so between 122 and 126 AD Hadrian had his famous wall built to keep them out. That didn't really work either, as a brief glance at the composition of almost any of the British Cabinets of the 20th and 21st centuries will testify.

But the Romans were only the beginning of the uninvited molestment of ancient England. In 449 AD the Jutes invaded Kent and the hop industry was kick-started (the Romans had already planted vine-yards right across the country, even as far north as York; and to this day the most successful English wines – rather few, it must be said! – are to be found on sites that were originally Roman), and just half a century later, in 500 AD, the Angles and the Saxons piled in after them. The melting-pot society was under way, and those who didn't like it probably ended up in the pot themselves, figuratively speaking.

Then almost 300 years later, in the 790s, the Vikings (G.K.Chesterton's "great beautiful half-witted men from the sunrise and the sea") began their raids, which intensified in the mid-830s, so that by 860 the Danes had established a North British Kingdom and serious confiscatory taxation began in the form of the iniquitous Danegeld.

The Danes were real go-getters. At the turn of the first millennium the splendidly-named Sweyn Forkbeard of Denmark saw off poor old Olaf of Norway at the Battle of Svolder, and Norway became Danish. Meanwhile Ethelred II was on the throne of England, where in 1013 Sweyn led a second Danish invasion and kicked him out. Ethelred's patience was hardly tried, however, as within a year of his exile the Forkbeard was called up to Valhalla, and Ethers politely accepted an invitation to return and resume kingship as usual. Poor Ethelred the Unready! In 1016, within just a year of his return, he was replaced by Edmund Ironside; and then bad luck for Edmund too, for in the very same year he was knocked off his perch by Sweyn's son Knut, he who we know as Canute who allegedly instructed the tide to turn back. This was in fact a very clever trick: you place your chair (or your throne if you're a king) just above the high water mark, and

when the waves lap just beyond your boots you regally command them to withdraw which, unless you have miscalculated the high tide mark or are ignorant enough to have chosen a Spring tide, they will dutifully do. And if you get it right, it doesn't half impress the natives!

Well, Knut had been unimpressed enough by the situation in England to have decided to invade it himself, and this created a line-up of Danes versus Saxons, Angles, & Jutes, with presumably only a vestigial remains of Ancient Brit population, if indeed any at all.

Why do I recount these things? To illustrate just how and indeed why there were so many early influences upon our English landscape, and later to show how, while the kings made the headlines in the mainstream of history, it was that countless army of footsoldiers and camp followers who made the realities of local history, who founded the folklore, and who in many cases became legends themselves.

Knut was the first ruler to divide his fief into an early version of devolved government. He created four earldoms in Wessex, Mercia, East Anglia, and Northumbria – earls had real clout in those days – and he left them to administer his conquest while he pushed off back to Scandinavia where, in 1028, he captured Norway again just as his Dad had done back in '13. But on his death in 1035 the Danish Empire split, as empires usually did when the strongman was no longer at the helm, and his bastard son Harold Harefoot ruled England as Harold I. Anecdotally, five years later Macbeth became King of Scots, lasting 17 years until his defeat by Malcolm Canmore at Lumphanan. Never a moment's peace!

The Normans then took centre stage. In the early 1060s they began their conquest of Sicily, that most

stunningly beautiful of all islands in the sun, which is how Palermo so unexpectedly has such a fine Norman cathedral; and in 1066, as every English schoolboy learns, Harold of Wessex had a very busy and a very bad year, initially succeeding Edward the Confessor to the English throne, and then losing it along with his life in a field near Hastings to William of Normandy (Guillaume le Conquérant) who later rampaged right on up into Scotland, as the Romans had done before him, installing his brother as Archbishop of York along the way in 1067.

Yet, as I say, how little we know about these rulers' supporters down the line. The principal lieutenants – the earls and the barons – yes; but the truly local movers and shakers, the enablers and the apparatchiks who really ran the show at town, village, and hamlet level, only appear by accident in gossip and hearsay, in village and rural scuttlebuck, and in the tales handed down across the generations in such close-knit communities as somehow survived the turbulent centuries of displacement and transportation, both voluntary and involuntary, that resulted from an ever more mobile society.

You will not find their tales in history books, nor in the County or the Town Hall records, though many would have existed and then perished at the time of the Dissolution of the Monasteries, that terrifying era of conflagration and destruction when so much that was recorded by those few who were able to write down for posterity what the whole world knew was swept away in the firestorm, rather as so many of the records in the old French town halls ("mairies") were lost at the time of the Revolution.

Finding out about local history can be an arduous task, dependent as much upon handed-down information as upon anything actually recorded. So much has to be pieced together from the scraps and

tidbits available that accusations of conjecture cannot by definition always be avoided, nor indeed should they be. All old jigsaws have pieces missing, and we have to do our best, mentally, to fill them in as we think logically they would have been. Thus the tapestry of history, full of holes, rife with speculation, presents itself to us as a canvas constantly awaiting informed or imaginative repair. We can but do our best to combine both qualities – and then effect the repairs with all errors and omissions accepted!

LOOSE CHIPPINGS

As the American tourist in England famously and apocryphally said, "Ah've seen signs to Loose Chippings all over the goldarn country, but ah'll be hornswoggled if ah've ever bin able to find the place!"

Well, it's either in the language, or the pronunciation thereof.

Indeed there's quite a bit of Chipping about. Both Hertfordshire and Lancashire have a Chipping each; London has Chipping Barnet; Essex is well-equipped with both Chipping Hill and Chipping Ongar; Northamptonshire has Chipping Warden; and Gloucestershire takes the cake with Chipping Sodbury (don't ask) in the far south, Chipping Camden in the north, and Tetbury, with both "The Chipping" and the Chipping Steps in the middle, while just over the county border in Oxfordshire there's Chipping Norton.

What does it all mean? The standard reply is that "chipping" simply means "market", and indeed all were once (and many still are) market towns and villages, often associated - particularly in the Cotswolds - with the wool trade; and wool and sheep markets always brought shopkeepers in their wake, so that wherever there were wool or sheep auctions there arose a retail centre to cater to the influx of visitors from the countryside.

But why "chipping"? Well, again very simply, it was most probably an early pronunciation of our word "shopping", derived from an early Anglo-Saxon word. So our ancestors, when in need of a spot of retail therapy, went chipping. When the mood took them, they toddled off down to the chips, where they merrily chipped 'til they dripped. No more complicated than that! And what do you find replaces the modern-day car park in The Chipping at the top of the ancient Chipping Steps in Tetbury on certain weekdays to this

very day? Yes: the market.

The "Cotswold Chippings", notably Chipping Camden, Chipping Norton, and Tetbury of Chipping Steps fame, have all become very prominent centres for the Antiques trade, and all are a "must visit" for browsers and collectors visiting the region, along of course with Stow-on-the-Wold, Broadway, and Moreton-in-Marsh, Stow and Broadway being among the most renowned such towns in the whole country.

Chipping Camden is an architectural gem, built in that 17th and 18th century honey-coloured stone that on sunny days has the whole town basking in an auric glow that so typifies the lovely villages of the North Cotswolds. How Goldfinger would have approved! Few small towns of the period can have comprised so many fine houses so delightfully landscaped with communal grass and trees. It is an ancient spot. By the mid-13th century it already boasted a weekly market and an annual 4-day fair, and by the early 14th century it was an established wool centre, wool being England's major export at that time.

Parts of the mediaeval houses of the most prominent wool merchants remain to this day, and their proud owners would have financed the magnificent Perp church of St James, south of which the great mansion of Sir Baptist Hicks, the wealthy mercer ancestor of the Earls of Gainsborough, was built. Sir Baptist was closely connected to the Stuart court, and Camden House, which was completed in 1620, was a quite extraordinary Jacobean mansion. Alas it was only to survive for a quarter of a century, when in 1645 retreating Royalist troops burnt it to the ground. Happily its lodges and great gateway remain to give us an indication of just how magnificent it must have been; but it was of course the17th and 18th centuries that gave us the Chipping Camden that is the jewel we have inherited today,

and that no visitor to the Cotswolds should leave undiscovered.

Chipping Norton is also a fine example of the evolution of a wool town, but it remains a crossroads and would greatly benefit from an improved road system that took through-traffic away from the town centre. It is a market and an antique centre of great charm, to which attached a little-known legend dating back to the tribal Ancient Britain of Roman times.

It seems there was a small Dobunni settlement on the hillside at the spot where Chipping Norton would one day be built, which served as a meeting-place for emissaries from both the Atrebates in the south and the Catuvellauni in the east. Here the Tribes would meet in secret to discuss British policy towards the Roman occupier.

From time to time they needed to get messages to each other quickly, sometimes to prepare for anticipated movements of the Roman legions, and the fastest method was inevitably by chariot along the principal Roman roads that crisscrossed the country. These roads were regularly patrolled by Roman troops, so they needed a Roman to drive the chariot, a Roman whose loyalties might conveniently be divided.

They found their man in one Gaius Clarcus Dobunnorum, the son of one of the most senior centurions in Corinium who had married the daughter of a Dobunni chief. The young Gaius Clarcus had shone both as scholar and soldier, and had taken the greatest interest in Tribal affairs and in the fostering of constructive relations between the conquerors and the indigenous population. He became a most effective intermediary, and he had one special attribute: he loved speed.

Year after year he won every chariot race in the

region, setting records that had hitherto been considered impossible on two wheels; and consequently, once he was off, no-one could ever catch him.

So Gaius Clarcus became the first inter-tribal messenger, the Fosse Way Formula driver, of whom all most people ever saw was the cloud of dust in his wake as he thundered up from Corinium to visit the Catuvellauni or the Corieltavi at Venonis (High Cross) or Lindum (Lincoln), or as he raced down to Aquae Sulis (Bath) or to their capital at Venta Belgarum (Winchester) to see the Belgae, or when he hurtled south-east from Corinium to Calleva Atrebatum (Silchester), the stronghold of the Atrebates. They said his chariot had wings, as had his go-fast, swept-back helmet, the original inspiration for those of today's racing cyclists. He was almost certainly Britain's first Road Hog, scattering other road users before him in a thunder of hooves and a whirr of bladed wheels on cobbles, returning at night whenever possible to his peaceful hillside dwelling where Chipping Norton would one day be.

Of course Gaius Clarcus consistently won the Corinium champion charioteer's trophy, and in time the Gaius was dropped and he simply became known to the whole world as Clarcus Rapidus. After he was demobbed on his well-earned retirement he stayed on to farm in what we now call Oxfordshire, whence it was said that he once reported directly to Caesar in person on the strange appearance of circles and patterns in his summer crops, phenomena for which the greatest sages of the Empire had no valid explanation. Some suspected that they were made by Clarcus Rapidus himself, driving his chariot in astoundingly fast circles in his fields, the whirling knives on its wheels threshing furiously; but as no access channels were found to these perfect patterns, that theory was quickly discarded. Today the same

summer phenomena appear further to the south, in Wiltshire and even parts of Hampshire, where charioteers have not been seen for almost two thousand years!

It is said by the older country folk around Chipping Norton that the spirit of Clarcus Rapidus still roams along the tracks of those ancient Roman roads, and that eddies of dust may sometimes be seen where his ghostly chariot has passed by. But some suspect they are more likely to be caused by some souped-up SUV, perhaps a giant Volvo, as the shade of the early speedster would surely have watched with ever-increasing joy as ever-faster cross-country vehicles are devised, and he would long ago have abandoned his chariot for the back seat of an unsuspecting modern road hog's fatcat-mobile!

And finally, what of Tetbury and its glorious Chipping Steps? Well, thereby hangs a very different tale.

In the mid-eighteenth century a dwarf breed of dog, somewhat resembling a bulldog in miniature, became all the rage. It was a dog of character, very much "its own man", and, after the common expression for an imp or even a small demon, it was called a Pug.

Its face was squashed, its nose flattened, so that people of a similar appearance (and in those days there were many) were described as "puggish". Pug was also a term first used in the early part of the century for a courtesan or mistress, even a harlot. And finally (and quite irrelevantly) in the Anglo-Indian mid-nineteenth century "to pug" was to track one's objective by its footprints.

Now it seems there dwelt beside the Chipping Steps in the 1770s a certain Quinnius Titubant-Pshaw, a scholarly gentleman who was greatly admired by the

ladies of the town but who, rather as his name might imply (like Mr Lemon the fruiterer or Mr Beef the butcher), was wont to wobble a bit on his pins, especially on his way home from a jolly night at the alehouse across the square.

It happened also that in a nearby house there lived Nell Flynn, mistress of the local earl, a lady who was in effect a pug with a very fine Pug of her own. One night the merry Quinnius Titubant-Pshaw was wending his customarily erratic way home when he tripped and found his chin upon a Chipping Step, facing up to the market square, at the very moment when fair Nell and her magnificent black Pug began their descent. Suddenly the little dog stopped, and its eyes popped more than usually as it found itself literally face-to-face with the venerable scholar who had never seen such a vision before. The Pug snorted, then sneezed at him, which is always a sign of great pleasure among those of

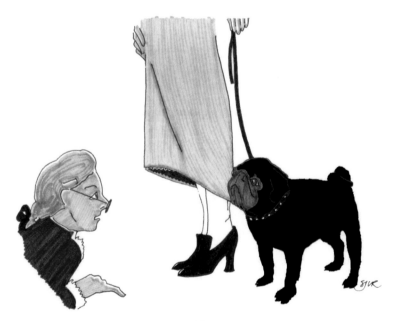

the canine persuasion, before, with a characteristically disdainful glance, it began to make its way around him. Quinnius watched in wonder, and swiftly invited the dog and its mistress into his parlour for a neighbourly nightcap. Neither she nor the Pug ever left.

Abandoning work on his tome on The Greek Empire in Mesopotamia, Quinnius began his great Treatise on Pugs, *In Pugilio*, and began to breed them as a part of his seminal study. Eventually he and Nell acquired three adjoining houses on The Chipping Steps, knocking them all through to form one single spacious townhouse to provide suitable accommodation for what became their family of fifteen Pugs, and folk would come from miles around to admire this unique and charming domestic scene. Nell and Quinnius married, the earl having received his marching orders, and both lived to a very great age; and for a century after their deaths the town preserved their house as a Pug Sanctuary, where lost or distressed Pugs would always find a home.

To this day it is said that every Pug that passes down these steps where once the sanctuary stood stops, stares, and lifts its leg in tribute, while other lesser breeds pass by obliviously.

CIRENCESTER PARK - IVY LODGE

Cirencester Park, a vast domain that stretches out from the town and its imposing Mansion into the rolling Gloucestershire countryside, is one of the best-run and maintained estates in England. Woodland and farmland alike are managed with expertise and enthusiasm (and, insofar as dendrology is concerned, with encyclopaedic knowledge) by the present scion of the family who is a professional farmer to his fingertips; and in the middle of all this lie the famous polo fields that are the scene of hard-fought contests between some of the world's greatest players, including England's future King and his superbly equestrian sons. The simple clapboard clubhouse has that low-key charm that is a characteristic of so many of our oldest and most revered institutions, and that sets them apart from many of their brasher New World counterparts.

Under a hundred yards from the clubhouse, and facing out across the Park and the principal polo field, stands Ivy Lodge. It figures on the local map, above Pope's Seat and to the east of Oakley Wood, which was named after the beautiful Madeleine, allegedly a wizard's daughter, who lived there in the Dark Ages and lured many an Errant Knight into her enchanted forest. No visitor to the polo grounds can have failed to be intrigued by the castellated façade of the Lodge, behind which in fact there lurks a charming Cotswold house with most delightful gardens; but from the south it looks for all the world like a converted castle, and this indeed was the intention, for originally it was built in the 18th century by the then Earl as a folly to adorn his Park, very much in the tradition of that age.

What however is much less well known is that the folly was constructed upon the foundations of a far more ancient dwelling built in the mid-15th century that would, a hundred years later, house a very special guest from Holy Russia.

When the original house was built, Ivan the Great (Ivan III) was Tsar; he was succeeded in 1505 by Vasily III, and then in 1533 Ivan IV, better known as Ivan the Terrible, came to power and held it for an astonishing 51 years. He was the first Tsar actually to be crowned (in 1547, so it was something of an afterthought), instigating a monarchy that only ended with the abdication of the ill-fated Nicholas II after the Russian Revolution. Ivan was a tyrant and, rather like his dictatorial successor Stalin, even his own family were not safe from him if he suspected they had stepped out of line. His empire stretched across the Russias and the vast steppes to the Pacific Ocean, and his henchmen ensured that in every far-flung province and "oblast" his will would be obeyed.

Like many Tsars (and Kings and Presidents and Princes), Ivan had his mistresses; and in particular one Katarina Leyaskova, a provincial Princess known in Court circles as The Minx from Minsk, who bore him a fine son that so closely resembled him as to become a potential threat. But Ivan, for all his brutality, could not bring himself to butcher his own son, his Dimitri (or "little one"), and he resolved to send him with his mother into exile. He wanted them to be very far away, beyond Continental Europe if possible, and to live a quiet country life.

Thus it was that the lovely and exotic Princess Katarina from Minsk arrived in London in about 1560, where the Imperial Russian envoy to the newly-crowned Elizabeth I was a great hunting man who had often joined the Royal Hunt as it galloped through the forests of the west. And it seems that His Excellency had by chance one evening found himself at dusk in what is now Cirencester Park, and had been provided with a bed and a fine feast at the then Ivy House by Sir Robert Quin, a noble knight and favourite of the Queen, who was preparing to sail with Raleigh to the

New World where he eventually settled and founded an American dynasty.

The Ambassador, remembering this hospitality and the fact that his generous host had announced plans to adventure across the Atlantic, and faced with the pressing need to find a comfortable but suitably remote lodging for his Emperor's mistress and their son, at once thought of the genial Sir Robert who, in view of his impending departure, was indeed delighted to find occupants for his woodland home. And so there they found their refuge, and there Dmitri grew up and eventually married into the English aristocracy, taking and anglicising his mother's family name in order to preserve his descendents' safety by disguising their imperial connections.

Five centuries later, by a strange coincidence a tenant of Ivy Lodge had the same surname, preceded by that of the tyrannical Tsar who founded what became an English bloodline, but as far as anyone knows he was blissfully unaware of the historical between his name and the house he rented up to his untimely death. Perhaps this was the closing of one of those vast circles of existence that sometimes take scores of generations to complete; or perhaps, as they say in that New World where Princess Katarina Leyaskova's genial landlord settled half a millennium ago, it was all pure happenstance.

THE MERRY KNIGHT OF STRATTON

On the northern edge of Cirencester lies the village of Stratton. While the greater part of it would seem to have been built in the 19th and 20th centuries, there do remain some vestigial origins, and if one delves a little one uncovers the occasional tale that, like so much of our folklore, provides a further enchanting element, another cameo, in the rich tapestry of our island's history. If, as one leaves Cirencester on the Cheltenham road, one turns off to the left down the hill towards Daglingworth, one almost immediately stumbles upon the charming little Stratton Church. It was first mentioned in Domesday Book, though sadly nothing remains of the original Saxon building, albeit the church is well-known in the region for its Saxon carvings. However, the south wall of the present church that was entirely rebuilt from 1850 onwards comprises the south wall of the Nave of a church built on the Saxon site in the early twelfth century, and interestingly this old part of the south wall still retains a small contemporary Norman window that attests to the Norman origins of that 12th century construction.

Norman society moved almost wholescale into England in the wake of William's invasion, and one of the proudest boasts of an Englishman today is that he "can trace his ancestry back to The Conquest" – rather a curious source of English pride considering the somewhat scratchy Anglo-French relationship following literally hundreds of years of wars between the two neighbours! But there it is – the Norman pedigree is held in high esteem, and hereditary Norman titles, albeit later considerably anglicized, are highly prized.

It seems that the earliest records did mention one Sir Geofroy de Jakes, Knight of Stratton, whose delightful motto was allegedly "Je fays les playsantris", or in modern French "je fais les plaisanteries", which

would broadly translate into vernacular English as "I do the jokes". The name de Jakes would originally have been de Jacques (or James in English) and there appears to have been a Norman Château de Jacques near Lisieux that was most probably the original family seat in the Calvados region.

Sadly, it is not known what became of the de Jakes family, who would have worshipped at the "second" or Norman church at Stratton, as all documentation was lost at the time of the Dissolution; but folklore still recounts some of the exploits of Sir Geofroy, who was widely known for his humour and his seemingly endless mine of hilarious stories that he would regularly recycle in order to regale the groaning table at his legendary feasts which were attended by a group that came to be known as The Knights of The Festive Table.

These feasts would be held following a weekly ritual of broadsword "matches" in the de Jakes courtyard after Sunday matins. Notable participants would have been Sir Roger de Woodmancôte, later Earl of Draycott, one of the earliest military engineers whose double-wishbone petard was said to have a range of almost half a mile if fired from an elevated redoubt, an enigmatic and quizzically humorous character whose lovely lady Jacquotte de Bizou was exceptional in her scholarship and her ability to recite entire chapters of Beowulf to the admiring assembly; then Sir Ivan des Champs, Knight of the Lea, renowned as widely for his horsemanship as for his bonhomie, and his gentlest of ladies; Sir Robin des Bois and his fair Madeleine, the sveltely curvaceous Lady of the Oaks; the awesome and adventurous Sir Michael, sleek raven-haired Knight of Gryn, whose tales of derring-do in what were then known as the Elfin Wars across the Welsh Marches had so often held the merry throng agog while his wife busied herself redecorating castles the length and breadth of the land; Sir John de Loge, a wickedly

urbane and worldly swordsman and notorious jouster, and his darkly exotic lady from a far-off land; and the wise and charming Sir Miles de Meysey in his signature black doublet, known to his peers as The Dapper Knight, who had notably married the much-loved Anne of Marston whose charity and myriad kindnesses were legendary. Naughty Knights and Lovely Ladies all, theirs was a company that truly made the welkin ring, and all who joined them at Sir Geofroy's table to share his bounty and his "playsantris" declared the world a better place withal.

There was one notable occasion in his later years when Sir Geofroy's humour and his hospitality literally saved his life.

Up on the hillside above Stratton to its south-west there is a level plain of fields – where today's Cirencester Park polo grounds are situated – where Knights of the surrounding Shires used to gather for their jousting tournaments; and here Sir Geofroy's prowess was never seriously challenged. For two full decades he was the undisputed Champion of the Lists, and as such had won the coveted hand of the fair Lady Jennifer whose name was an adaptation of Guinevere, the legendary wife of Arthur of Camelot. Her beauty was sung throughout the West by the troubadours of the day, and she is credited with the invention of what became an immensely popular decoction of crushed tomatoes, spices, and mead that was the precursor of that great pick-me-up of our own age, the Bloody Mary.

One day, however, a much younger, rather pushy knight arrived in their midst from the distant capital. He was socially ambitious, eager to impress, and his reputation as a jouster was that he was liable to lance you when you weren't even looking. Being short and round, he was also a smaller and more elusive target than the burly Sir Geofroy, whom he was determined

to unseat, partly so that he could establish his own rival Festive Table in the latter's place.

It must be remembered that by now Sir Geofroy was past his jousting prime. The eye was watery, the joints creaky, and his prospects were frankly not auspicious. But Little Sir Piers, as his young challenger was known, was extremely fond of his food, and readily accepted Sir Geofroy's genial invitation to a Great Feast on the eve of the Autumn Tournament. And a very great feast it was indeed – Sir Geofroy and the ever-hospitable Lady Jennifer saw to that. Soups were followed by a variety of fishes, and fish by many a vast fowl including roast swans from the de Jakes' mere, and then two great oxen were turned upon a giant spit, and all the while the mead and wine flowed, and Little Sir Piers's goblet was kept brimming by the attendant flunkeys as toast followed upon toast.

Then, as the feast progressed, Sir Geofroy began to tell his tales. He told the one about the Dane, the Jute, and the Angle; he told about the Pict, the Goth, and the Visigoth; about the Squire, who so hated his Knight that, just as his master was about to ride off into battle, he poured a whole red anthill into his suit of armour; and as he spoke, he urged Little Sir Piers to eat more and more, and to drink up merrily, and the poor little podger was all the while so suffused with laughter that first this gave him the hiccups, and then he had a seizure, and finally, as he was demolishing a rib of ox and quaffing the remnants of his goblet and Sir Geofroy reached the dénouement of the one about Ethelred the Unready and the Naughty Nun of Stroud and then clapped him heartily on the back as he roared at his own excellent joke, Little Sir Piers' face went a bright purple and his hand clutched at his throat, and with a muffled grunt he pitched forward into the remains of his dinner, as dead as if Sir Geofroy's lance had on the morrow found its target and pierced him to

the heart.

Je Fays les Plaisantris – I do the jokes – it might as well have been "make jokes, not war", so deadly effective was it; and many agreed that night that his humour had probably saved the jolly old raconteur from an otherwise grisly end in the next day's tournament.

It is said that he and all his Knights Of The Festive Table lived to a ripe old age, their goblets raised and their laughter echoing round the rafters of the great hall down through their festal decades. And when you visit the delightful little church at Stratton, now in its third architectural incarnation, spare a thought for the Merry Knight and his lovely Lady: who knows, they may even be watching you, and smiling.

ITLAY TALES

Sir St John Danglingworthy & The Lusty Lodger

Sir St John Kingdom Falstaff Danglingworthy, or "Sinjer" to his friends, lived the quiet life at Dogg Hall, his estate at Itlay near Cirencester.

The 19th century was drawing to a close, and all the glorious, comfortable certainties of Victorian life combined to bolster and to reassure the country gentry of which he was, in his own words, the living epitome.

"It's a grand thing," he was wont to inform any visitor to his house who cared to listen, "being a Living Epitome. One knows who one is, and one knows just where one stands."

When he drove into town in his rakish and well-sprung coach, and strode about the Market Place doffing his top hat to the many ladies of his acquaintance, often with a slight inclination of the head or even a half-bow if they were from The Park, people would seek him out and fellow-epitomes would mutter "howdee-do" and touch the brims of their own hats as they passed. His was a bucolic existence, a life of which he was just as naturally sure as was the world of his acquaintance that knew him and afforded him due recognition.

At the entrance to Sinjer's estate there stood a pair of lodges, quite literally his guardians of the gate. One was inhabited by tradition by the last retired head game-keeper who acted as watchman over his master's entrance; the other was loaned or leased to family or to recommended tenants according to their needs. Built in the early Georgian era, they were small but handsome residences and one day, just after St John had received his knighthood for services to the booming parrot trade, he received a letter from his old Oxford friend, the newly-enthroned Bishop of Limpopo,

asking him if by any chance he could accommodate his niece whose husband, a missionary in very darkest Africa, had recently died of Mzango Fever while attempting unsuccessfully to convert the entire tribe of Obongo cannibals to the Ways of the Lord.

It was of course impossible to refuse such a request from a fellow-student of Herodotus, and so it was that the ravishing Gloriana d'Etang de Foie was invited, sight unseen, to the Danglingworthy estate. Gloriana was, as they said even in those days, "a girl who'd seen the world". She was widely travelled and had been about in the broadest sense, and duly learned from everything she saw and did. Though she was herself of modest origins, having been christened Gloriana by an ambitious mother in honour of her own heroine, Elizabeth the First of England, her late husband's family were the d'Etang de Foies from the Landes in south-west France, nobility from the Ancien Régime who had fled the ravages of the Revolution for the kingdoms of the north, living variously in Holland and England, and many had converted to Protestantism and entered the Church, where for the most part they had prospered.

With a name that literally translates as "pool of liver", said to derive from the lakes (étangs) of the Landes that are home to the duck and geese that yield some of the finest foie-gras in the world, it was hardly surprising that in an Anglo-Saxon context she should swiftly become known as Madame Liverpool or, to the many that she failed to impress with her preternaturally haughty manners, as Milady Liverpool.

All this was in the future when she arrived by the new steam-engined train in Ciren, to be met by Sir St John Danglingworthy's trusty factotum, Mr Grode, and driven in his pony and trap on a beautiful autumn day to the lodge that was to be her home for the next several turbulent years.

Silas Grode was, like his employer, also a quiet man, and one who kept very much to himself. His was a life of dedicated service to his master, a life of diligence and duty, informed above all by the virtues (as he perceived them to be) of orderliness and predictability. He was therefore somewhat unprepared for his quite stunningly good-looking passenger, truly "a most handsome woman" in the terminology of the day, whose first question as she climbed into the trap and surveyed the quiet country town around her was "Well, Grode, where's the action in this place?", a remark, had he but known it, that put her a good century ahead of her time. His reply of "Ah, Ma'am, there's a marvellous great crowd in town on Market Days, every Monday that would be, quite a commotion it all makes, to be sure," was hardly what the newcomer had been hoping for nor indeed quite had in mind, but with a winning smile and a toss of her flowing golden locks she replied spiritedly "then, good Grode, you must drive me in for it," at which they set off at a brisk trot up the dusty highway to Itlay and Dogg Hall where Sir St John Danglingworthy awaited them.

All Sinjer knew of his new tenant was her name and that she was of presumably foreign origins. The Bishop of Limpopo had not so much as hinted at her age, and somehow Sinjer was expecting a rather plain woman in her middle years, such a companion as might befit a missionary in the depths of unexplored jungles. So when a rather flustered Grode arrived at the Hall with the ravishing Gloriana, Sinjer's countenance formed itself into the very model of embarrassed perplexity, a condition not unakin to that of a clergyman when first confronted with the naked fulsomeness of the Archdeacon's daughter he has just married.

In a word, Gloriana's benefactor was smitten, a state of affairs the lady had oft encountered and took merrily in her stride, thanking him warmly for his exceptionally generous hospitality and trusting that he would introduce her to his beloved Cotswolds "if ever he had a moment to spare for such frivolities". Oh, how she charmed him with such modest diffidence, and how she beguiled him with her winsome smile.

This might all have presaged a state of at least potential serendipity for the parties concerned, had there not been but one somewhat complicating cloud in their sky: there was a Lady Danglingworthy, and she had been the Mistress of Dogg Hall for a score and a half years, during which she had systematically "seen to the Devil" a string of temptresses who had crossed her husband's path or indeed caught his almost pathologically roving eye.

Lady Danglingworthy was a fine woman, widely admired both for her character and her own powerful attractiveness, and Sinjer knew that it would be more than his tranquil life was worth to maintain anything but cordially formal relations with this new lady who was now to be literally on his doorstep, if the most igneous of sparks were not to fly. Indeed this became at once luminously clear to Gloriana as a smiling

Hortensia Danglingworthy appeared from the gloom of the hall behind her husband's shoulder and extended her hand to the new arrival.

"So very glad to make your acquaintance, my dear," she gushed, "and I know at once that we shall be the best of friends. Of course I shall make it a personal mission to show our beautiful Cotswolds to you myself, as Sinjer is so occupied with the running of the estate. Now I insist you take luncheon with us and tell us all about yourself."

And thus it was that Lady Danglingworthy introduced Gloriana d'Etang de Foie to the cream of Gloucestershire society, thereby starting a small snow-ball rolling; for Gloriana began to receive a steady stream of callers at her Georgian lodge, including many a scion of the great houses of the county and many a young blade unashamedly on the qui vive... and sometimes, even their fathers would make the occasional discreet visit. All were received in great good humour and, so it came to be rumoured, few departed entirely disappointed. It was said that Gloriana had picked up many a curious custom in Africa during her husband's long absences up river among the tribes, and that she proved a source of the most unusual delights to her increasing circle of admirers. Perhaps inevitably, therefore, word of her talents began to filter through the smoking-rooms of the mansion clubs of St James's until they reached the ear of a certain Duke of the royal blood who was known for his enthusiasm for the customs of the more exotic reaches of the Empire, and who regarded every broadening of his experience as a most virtuous necessity for a man in his position.

His Grace let it be known that his curiosity must absolutely be satisfied, and ordered his private carriage to be affixed to the steam train to Cirencester, where he was met by no lesser personage than the local earl, at whose mansion he was duly lodged. A glittering Ball

was then given in his honour, and among the many distinguished guests from across the county were naturally Sir St John and Lady Danglingworthy and the Lady of their Lodge, as they had come to know their tenant.

All were presented to the Duke, and when he set eyes on Gloriana he knew she had to be his. But Gloriana knew just how to play hard to get. She recognized that while some gifts are priceless, their value is all but lost once given. Having lived beside a mighty river, she knew that while fishing requires infinite patience, catching a big fish requires artistry as well. Thus, just as His Grace made clear, albeit charmingly and diplomatically, what his intentions were, so she appeared confused, uncertain, reticent, and somehow seemed not quite to catch his drift, leaving him in turn unsure and even unhabitually anxious, fearful he might have been misinformed and therefore may have caused her great offence.

He was on her hook, and she played her line with all the skill of a master of dissemblance, so that as she took her leave to return to the company of her benefactors at Dogg Hall, the Duke all but begged them that he might call upon them on the morrow, to the utter delight of the Danglingworthys who had never dared hope to receive so illustrious a visitor.

Thus, while Sir St John Danglingworthy looked on, grinding his teeth at having been unable to pluck the peach from the tree outside his own window but revelling in the kudos of his newly-acquired royal connection, there began under his very nose one of the great romances of the end of the nineteenth century. Oddly, if the old Queen knew of it she didn't raise any great objection, perhaps on the reasonable grounds that, in the words of one of her more pragmatic courtiers, "it kept her son off the streets". For their part, the Danglingworthys were frequently honoured

to play host to their royal guest who would not over-trouble them to attend to him as, once arrived, he would spend much of his time "just poppin' down to the Lodge", and Gloriana had her time cut out discouraging further visits from her "country gentlemen" until word got around of her now rather more exalted status.

Sadly Dogg Hall no longer exists. An early Zeppelin raider heading for Bristol got lost in low cloud and dropped its entire load of bombs on the estate, destroying the Hall and both Lodges. By then their erstwhile occupants had long passed into history and become the stuff of local legend, and Dogg Hall had somewhat perversely become a cattery run by Mr Grode's great grandson Ernie, with the assistance of his buxom wife Doris. Happily, both were at a lantern show in Cirencester at the time of the mistaken air-raid, though the feline losses were accounted to be substantial.

CHEDWORTH

Corinium and The Yanworth Centurion

Just outside Chedworth, a bare half-hour's brisk chariot ride up the Fosse Way to the north of Corinium (today's Cirencester) there lies one of the most luxurious and obviously important Roman villas in the West of England.

No-one seems to know for whom it was built, but that is probably because their inquiries never sought beyond the records of the region. To find the answer, one needed to search as far away as Italy, to the very heart of the Roman Empire.

Most archaeologists accept that the Chedworth Villa was a part of the Imperial Domain – in other words, a residence in the Emperor's gift that would revert to the Estate at his will or upon the death of the occupant, which presumably could always be arranged; but for which occupant was it built so sumptuously, for which favoured son of Rome was it so meticulously – even lovingly – created?

In BC27 Octavian took the name Augustus and became the first Emperor of Rome, beginning the famous Pax Romana (Roman Peace) that was to last 200 years. Three Emperors later, Claudius oversaw the invasion of Britain in AD43 where, after Londinium, Corinium grew to become the most important Roman city in the country.

The invasion was a great success. Apart from the brief revolt led by Boudicca in AD61, Rome occupied Britain largely unopposed, with Hadrian's Wall keeping out unwanted Picts and Scots as already mentioned.

Conventional wisdom has it that Corinium (thus Cirencester) took its name from its river, the Churn, and that the Ancient Briton inhabitants of the early settlement in the region at what today is Bagendon,

the Dobunni tribe, knew it as Caer-Coryn. Caer means simply a fortified or enclosed place, while Coryn signifies the highest point of the river Thames. Druids have always regarded living near a source as auspicious, just as practitioners of the Chinese art of Feng Shui regard running or tumbling water as a positive element in the propulsion of chi or natural energy. When the Romans arrived they named their settlement Corinium Dobunnorum, literally the capital of the Dobunni. Later the Saxons modified the ancient Caer to Caestre, which in turn evolved into Coryn-Caestre, later Cirencester.

All well and good. But this overlooks the existence of a noble Roman by the name of Corinius. He and his brother Marcus, dei Valderani ex Sicilium, soldiers and senators both, had backed the winning side in the Civil War of 68 in Rome, and were court favourites when Vespasian became Emperor and founded the Flavian dynasty in 69. The new Emperor needed trusted hands in the north, and the brothers seemed ideal. Corinius had proven himself to be a born military leader, and Marcus was a gifted administrator as well as being one of the greatest geologists of the ancient world. Both had made their mark in the Senate and were generally regarded as "safe pairs of hands".

So Vespasian dispatched them with a legion at their command, and thus they marched up Europa and through Gaul, whence they embarked in galleys whose slaves rowed them over to Londinium. There the Roman governor of Britain, delighted with the arrival of additional forces and needing to strengthen his grip on the West, requested them to set out at once for the Dobunni settlement and expand the Roman presence there.

Thus came Corinius to what was to become Corinium, and while his job was to garrison the wider province of what later became Mercia, and to

expand Roman operations in the west generally, his brother Marcus, who by then was married to the Roman beauty Trivia, a lady famed for her vast fund of inconsequential information, was appointed Administrator of Corinium, the second Roman city in the land (a sort of first century Birmingham in effect); and on the orders of Vespasian himself a vast and luxurious Villa was created in the nearby countryside as a seat fitting for the Emperor's Pro-Consul (Marcus) and his Military Commander in the west of the island.

Here the Senator-brothers dei Valderani received all the great dignitaries of the Empire whenever they ventured over the sea to Britannia. From Senators to Consuls to weary Centurions they all found peace and plenty at Chedworth, and the Roman Games would take place each summer in the fields around what is now Yanworth, when the countryside rang with the clash of gladiators' swords as they slew each other to the cheers and deafening applause of the bloodthirsty toga-clad crowds.

It is said that the mightiest fighter of them all, one Gruncus Dobunnius, who had begun life as a Dobunni warrior and then been conscripted into the Roman army, was granted not only his freedom but Roman Citizenship for his indomitable gladiatorial performances in the Yanworth fields, and that he became a Centurion and eventually the Assistant Military Governor of Corinium. It seems that in old age Gruncus died at the hands of an assassin, said to be the brother of one of the many gladiators he had slain "on the way up"; and he was thereafter known as The Yanworth Centurion, whose spectre, it is said, to this day roams those fields on summers' evenings, pursued by the ghostly shrieks of his victims that are carried faintly on the wind that blows along the hedgerows and among the darkling trees…

BAUNTON

This is not an obvious village for a tourist to visit, and its residents wisely want to keep it that way.

Its church is nevertheless well worthwhile visiting. St Mary Magdalene's was originally Norman, and up to the Dissolution of the Monasteries it belonged to Cirencester Abbey. Restoration had left its most famous asset, a 15th century wall painting of St Christopher, in unusually good condition (the word "suspiciously" has more than once been evoked), but it does include a mermaid, attesting to an ancient belief in magical creatures juxtaposed to Christian icons. Also it includes some almost luminously blue and green fish, such as might appear in a modern naïve painting.

The village comprises a serendipitous mixture of 17th, 18th, and 20th century cottages and houses, the gem being what was once Manor Farm and is now the delightful Old Manor House.

Legend has it that there once dwelt there no less than three dashing tycoons, one a master of liquid transportation, one a future privateer of the skies, and one an impresario of national notability. Their wife, Schnapsina, who found in them one magnificently combined persona who embodied all the virtues of Victorian entrepreneurialism (if such a word exists – well, it does now!), was an exotically beautiful Central European aristocrat, the daughter of the notorious Count Strahov whose daring exploits once held the Courts of the Russian and the Austro-Hungarian Empires in thrall. Her mother was presented to the Tsar in St Petersburg and to the Emperor in Vienna, allegedly spoke nine languages and another thirteen patois, and was the God-daughter of the Grand Duke Stanislavski who invented the first industrial rasticulator and left her all the patents in his will.

Schnapsi, as Schnapsina was inevitably known, and her handsome husband(s) cut a dash wherever they went, and thanks to the generosity of her late mother's benefactor their own legacy enabled them to branch out into further pioneering research, notably inventing the Bigger Floating Box (in effect the daddy of all maritime containers), the microelectronic transpnondingdram that was later to revolutionise

NASA's approach to macrobionics and controlled locomotion in a gravity-free environment, and finally the exploding plastic seagull that, for the military, would transform frontal beach-head assault risks.

At social gatherings such as Longchamps or Royal Ascot, Schnapsi would wow the Enclosure with her sheer daringly translucent diaphanicity, causing admirers to form distinctly disorderly queues to kiss her hand and pay their mumbled respects, while her husband(s) collected exorbitant winnings from distraught bookies, literally having to load them into the cavernous boot of their limousine in order to transport them back to Baunton.

In Prague in the old days they used to say that when good fortune was exceptional, it was Strahovian; and clearly the luck of the Strahovs was powerful enough to pass down through the generations and their spouses, even to those in the depths of rural Gloucestershire.

Today the fields and water-meadows that surround this peaceful spot are the domain of a myriad free-range chickens, ducks, geese, and ponies. By night Monsieur Reynard is well provided-for, while by day the greensward rings with the happy voices of children as they play along the banks of the Churn, searching for Toad Hall.

But it was not ever thus.

Indeed there was a most unquiet event in Baunton, unexplained and inexplicable, in 1646 upon St Matthias's Day, which was duly recorded in the Parish Register by the Vicar at the time.

It happened in the house of the Clerk, a certain Master Sifolie or Syfolly. Quite suddenly, in mid-morning of all banal and innocent times, a liquid coloured like blood and of a similar texture began to gush upwards out of a dry wooden table, whence it continued to spurt and flow until the same time the

following day, when it equally abruptly ceased. It never occurred again, but chilling tales of The Baunton Blood have been passed on down the years among the older village families, some of whom still cross themselves nervously as they pass by those ancient premises. This is hardly surprising, as sudden eruptions of blood from inanimate objects have always rather caught people's attention, and tended to create a measure of disquiet...

Baunton shares with its neighbour over the hill, Stratton, a rather charming Easter tradition whereby their schoolchildren are given free hot cross buns by the Plough Inn in Stratton. It began before the First World War as a rather overt bribe by the then landlord, a Master Butcher, to stop the kids from knocking down the haystacks in his field; and then his successors maintained the habit, so that every subsequent generation has grown up with an inevitable soft spot for that particular pub, ensuring it an especially loyal clientele.

The blue and green fish in the picture of St Christopher in the church, which was almost certainly painted locally, no longer grace the Churn, and no more Baunton Blood flows from the local furniture. But who knows what strange tales yet remain to be enacted in this quiet corner of the Wolds, tucked away as it is in its hidden valley, where sudden mists wreathe the meadows where some still say the sheep stand on three legs on Walpurgis Night when Old Nick is supposed to be abroad.

PINBURY PARK

This remarkable house, standing as it does on a promontory overlooking the beechwoods of the Frome Valley, can be glimpsed from afar from footpaths that cross the hills from Duntisbourne Rouse to Sapperton, as well as from a right of way that passes down the drive to the side of the house.

It is a strangely forbidding building, with its roofs as pointed as witches' hats, but it is set in a quite idyllically peaceful spot.

The original property was owned by the Abbess of Caen until the Suppression of the Alien Monasteries in 1415, when it was donated to the Brigittine Nuns of Syon.

The house we see today was built in the late 16th century, but almost certainly comprised elements of an earlier 15th century building; and it was later altered in the late 17th/early 18th century by the county historian Sir Robert Atkyns, with even later additions in the 19th century. So many English houses have evolved in this manner over time, adding a little of the character of each age.

The greatest fame of Pinbury however comes from its association with Ernest Gimson and Ernest & Sidney Barnsley, three of the most active exponents of the Arts & Crafts Movement of the late 19th/early 20th centuries that particularly flourished in the Gloucestershire Cotswolds, where Gimson was the star performer.

He took up residence at Pinbury in 1894 together with the Barnsley brothers, where they created the superb modeled plaster ceiling in the library with its magnificent stone chimneypiece and its broad bay window that looks westwards to the towering yews of the mysterious and (some find) strangely unquiet

Nuns' Walk. They stayed eight years before building their own cottages to which they moved in Sapperton, where they then used Daneway House as both their workshop and the showroom for their finely crafted furniture.

Today the house and park, which are considered to be the jewel in the crown of the Bathurst Estate, are let privately. The poet John Masefield also spent eight years there between 1932 and 1940, no doubt dreaming of his beloved Sussex coast and its "lonely sea & the sky", although in 1940 it would have been a much-disturbed region while the Battle of Britain was being fought in its and the Kentish skies. Pinbury would have been a haven from all that; but while it is spectacular in its setting and utterly tranquil in its seclusion from the outside world, it is as I say a place that some would think unquiet, too burdened with history and legend for those that can sense the past's intrusions to be truly at peace there.

These hills contain so many bones of those who passed prematurely and unnaturally into that unknown country from whose bourne no traveller returns – even if they began their journey in the Duntisbournes! – that in terms of phantom demographics they risk being classified as seriously overcrowded.

It began so very long ago. The defenders of that Iron Age hill fort to the north-east of the Pinbury promontory were constantly being overrun and slaughtered by marauders from the Celtic west, strange hairy dark-eyed violent mountain men for whom all settlements were fair game, and who anticipated the Vikings by about 3000 years in their taste for rape and pillage. This was not a good time to hunt, gather, and man the hill fort at night, and many a lost soul mourns his grisly end on the spur of land on the hillside above the park. This would almost certainly account for the size of the Long Barrow in College Plantation just

under a mile away.

Then, in the last millennium, there was the fate of the Nuns. Pinbury Park, according to the historical notes provided, was a mediaeval monastic possession until 1539, though "probably never used as a monastery". But the great avenue of yews was planted, and was known since time immemorial as "The Nuns' Walk"; and at the time of the bloody Dissolution, many a nun as well as many a monk lost her or his head in what amounted to little less than pogroms. And the dead, and most particularly their unquiet spirits if they roam abroad, are said to be most especially attracted and indeed attached to yews, which is why one finds those trees in so many churchyards up and down the country.

They say the Nuns' Walk is no exception, and that on moonlit nights in certain seasons the shades of the mediaeval Nuns of Syon flit soundlessly across the far end of their walk; and legend has it that on Walpurgis Night the severed head of an Abbess, coiffed and grey, is known to float between the trees; and where its tears fall, pale crocuses spring up in the New Year as tokens of renewal both of spirit and of hope.

And finally there was the tale of the army that disappeared into the Gloucester Beeches, never to reappear again.

The Civil War of 1642/8 ravaged English society and resulted in the infamous Long Parliament over which Oliver Cromwell presided as Lord Protector of the English republic. In the mid-1640s legend has it that there lived in the old house at Pinbury a Royalist lady of great character, allegedly the descendent of a Norman baron, who was known simply to all the world as Sara of the Wild Woods for her habit of roaming happily and fearlessly in the depths of the dark forests that covered the surrounding hills. Many a King's

soldier found refuge in her house or was directed by her to safe hiding-places in the hillsides when Roundhead patrols were abroad, and it was said that she had the gift of communion with the Knot (in translation "the community") of Trolls who had come to Britain with the Vikings and who now inhabited these hidden, unfrequented hills and secret valleys with their dense beech woods. Whether these were the giant one-eye Trolls of Icelandic origin, or the cunning, dwarvish Trolls of Scandinavia who harboured a pathological hatred of noise after being so frequently bombarded by Thor's hammer, is not clear, but their power was undisputed and Sara was the beneficiary of their protection. They were quite definitely her Knot of Trolls.

On a summer's night in 1644 a bedraggled troop of defeated Royalist forces had finally escaped from a squadron of Cromwell's army that had pursued them from the Welsh border, and had found succour in an encampment on the Pinbury promontory where Sara of the Wild Woods was busy tending to their wounded. Then news came that the Roundhead squadron had picked up their trail again and was advancing down through the Gloucester Beeches with orders to eliminate them to a man.

In desperation Sara rushed into the woods to seek help from her mysterious Nordic friends. The message passed – and clearly received – she retreated back to her hilltop across the valley. At dawn the frightened and exhausted refugees heard the clatter of the small army descending through the woods opposite, and caught a distant glimpse of sunlight reflecting from sword and pikestaff. They were convinced their end had come. But then there was a mighty rumbling of the earth and the very trees of the forest seemed to bend and shake, and there were all the cries and chilling sounds of a sudden terrible battle... and then a great silence. Nothing in the forest moved, until after a long while

the birds began to sing again, and fox and badger ran among the trees.

Finally, after some further hours of silence, a Royalist scout plucked up the courage to descend into the valley, cross the brook, and climb up among the beeches.

He found nothing. Not a trace of a soldier or of his equipment, not a sign of human life or indeed that anyone had passed that way. An army had simply vanished, never to be seen again.

Understandably, no Roundheads ever ventured near Pinbury again, and while when the house was rebuilt there was no record of its beautiful, courageous former occupant, the legend of her goodness lived on for many generations. It is also said that if any great noise disturbs the valley, there is still a strange shaking and rumbling among the woods that continues until the peace of this utterly exceptional place is fully restored.

NORTHLEACH *and*
THE HAMPNETT HIGHWAYMAN

Northleach is a quintessential Cotswold town. As might be expected, it takes its name from the River Leach that springs in nearby Hampnett, as well as from an 8th century Manor also known as Leach; but as other settlements downriver also took the name, by about 1100 it had become North Leach, and by the early 1200s it was a market centre, which kick-started the local "rag trade" (mostly clothmaking) that was to enrich the town for several centuries.

Early records show a winemerchant in the town in 1221. By 1267 there figured among its burgesses two shoemakers, a baker, a cook, a weaver, a mercer, a dyer, and three smiths. A hundred years later Northleach's leading citizens included a group of woolmen who dealt with London exporters and who even traded directly with buyers for Italian merchants; and by the late 16th/early 17th centuries drapers, ironmongers, cardmakers, cheesemongers, cobblers & shoemakers, glovers, parchment makers, tanners, collar makers, glaziers, coopers & joiners, and even plumbers had added to the retail and services industry and the town had clearly become a booming regional centre.

Its chief asset lay in its communications. Originally it enjoyed the brisk traffic up and down the Fosse Way from Cirencester to Stow (the Roman Fosse in fact ran from Dorset to Lincoln, which was a very long march for a Centurion and his troops in more or less a straight line!), but by the middle of the 18th century Northleach found itself on the main highway from Gloucester & Cheltenham to Oxford & London. Indeed the record shows that by 1757 a stagecoach from London to Gloucester ran through the town three times a week, and that in 1785 the London mailcoach

to South Wales via Gloucester also passed through regularly.

This was of course all excellent business for the town's many alehouses and coaching inns, the first of which seems to have been The Crown, originally "le Pyke" that was recorded in 1539, and that remained in business until at least 1613. The White Hart also dated from the early 1500s. Then came The Antelope, followed by The King's Head, and later again The Lamb (eventually to become The Sherborne Arms), and these were the principal coaching inns of the eighteenth century. In 1755 Northleach contained no less than 14 licensed alehouses, doubtless to the delight of the regional brewers, and by 1794 The Wheatsheaf rose to a dominance that it has maintained to this day. In 1783 on the southern side of the Market Place there stood an inn called The Pound of Candles, which successively became The White Horse and The Wellington, a name to which many public houses across the country patriotically changed their old identity after Waterloo; and when the old Sherborne Arms eventually closed, it then took that name over.

All these inns provided plentiful accommodations for the many travellers (and their coachmen and horses) who either came to Northleach on business or who found it an agreeable and convenient staging post on their way west; and they also provided an opportunity for highwaymen, some of whom would doubtless have lived clandestinely in the town, their nocturnal activities probably blissfully unknown to their neighbours, to mingle among these often well-heeled passers-through, and thereby to target their prospective victims – but more of that anon.

The coach traffic was alas badly hit by the opening of a railway station in Cirencester in 1841, but by the 1930s motor traffic, that mixed blessing, not only brought back trade but with it a most disquieting toll

of car crashes by the Old Prison on the Fosse Way crossroads, eventually solved by the installation of traffic lights. Since then the proliferation of motorways and the building of a bypass have relegated Northleach to the status of a peaceful backwater, albeit still a regular source of accommodation for hunting folk and their horses when they come from their cities to ride to hounds in the Cotswolds, though even their traditional activities are banned or severely curtailed now, at great potential expense to employment in the countryside, by an uncomprehending "townie" and townie-elected government; all of which leaves the hospitality industry in the Cotswolds to depend largely upon today's international tourists who flock to soak up the ambience of these historic communities.

The history of Northleach is closely intertwined with that of its neighbouring village of Hampnett.

In 1791 one of the new "state of the art" county prisons, designed by William Blackburn in conformity with the principles laid down by the resoundingly-named Sir George Onesiphorus Paul, was built in the Parish of Hampnett at the crossroads where the recently-closed Cotswold Museum now stands. Its inclusion of exercise yards was a breakthrough in penitentiary accommodation, and a part of the premises later became a Magistrates' Court. A centre for Petty Sessions was added half a century later.

On the royal front, the Toms seem to have it. The records show that Queen and King have dined in Northleach: Elizabeth the First with her tenant Thomas Parker (later known as "Pickle Parker" as he was thought to be the first man in England to pickle onions in jars and sell them commercially, his descendents moving to Lancashire and founding an industry there), and Charles the First with Thomas Rowden. The future Charles III was reputed to dine regularly at the recently-closed and much missed

Woolsack, but then he is of course entitled to consider himself a Cotswold man.

Some say that if one had "made it" in Northleach, one moved "up" out of the valley to settle in Hampnett on the hill. It was where the smart set lived, and is very much the same to this day. Indeed Hampnett had always been highly rated ever since the time that Eldred, Archbishop of York, having bought the estate that included Hamnett from Edward the Confessor's minister, Earl Godwin, then gave it to the monastery in Worcester in about 1061. In the 12th and 13th centuries it was a cherished possession of the de Mortimer and then the de Breuse families, almost certainly descendents of the Norman invaders who always seemd to know a good thing when they saw it; and while most of Hampnett today is at earliest an eighteenth century rebuild, the cachet of its former inhabitants in the earlier centuries of the millennium had clearly "stuck".

What will not appear in the Parish records is the fact that Hampnett was also almost certainly the home of one of the eighteenth century's most glamorous – and inevitably notorious – highwaymen.

"Daring Dick" Dreadfus, widely held to be the Robin Hood of the Cotswolds, was, according to a neighbour's diary discovered by a descendant many generations later, rumoured to be a Gentleman of High Birth whose self-imposed mission was to redress some of the imbalances caused by the Accident of Birth; but whose appeal to those of the female persuasion was such that he had the effect of contributing equally frequently to the Prolixity of Birth in the general region of his activities.

His victims knew him as The Masked Cad, but to the poor to whom he gave so generously he was known as "The Most Shining Knight of the Shire."

It was said that in his gentleman's finery he would roam the inns and coaching houses of Northleach, mingling easily with his intended victims and learning of their imminent travel plans, in order to await them later on the road. Dick Dreadfus was reputed to be the best pistol shot in all England, and certainly no coachmen who resisted lived to tell the tale: to their fraternity he was better known as Dreaded Dick.

It seems he also had an accomplice in the person of the exotic and voluptuous Lady Koralia de Kuyper, whose aristocratic husband's father had come to England with William of Orange in 1688. It is quite possible that she was in fact Dreadfus's sister, and their strategy seems to have involved her in luring wealthy noblemen or merchants into a nocturnal carriage ride, such activities being known in those days as "nightly naughties" (as opposed to naughty nighties), when she would literally have them driven along her chosen route into Dreaded Dick's ambush, at which point she would scream and swoon as her and her distraught companion's valuables would be removed at pistol point; and afterwards the guilty companion would then feel obliged to replace the jewels that Lady Koralia had just "lost" in order to avoid her husband, the jealous and extremely dangerous Baron de Kuyper, from noticing their absence.

It was a perfect scam, and in addition Daring Dick was also known to be a scourge of lesser highwaymen whom he would pounce upon and rob just as they were escaping with the proceeds of their own hold-ups.

When the pickings were exceptional – and with Lady Koralia's help, they often were – Dreadfus, who termed it a "natural redistribution of wealth", would make a substantial anonymous donation to the local poor, either leaving it in an agreed spot in the little 12th century church in Hampnett where the rector, who was

also responsible for the church at Stowell, would pass it to the needy in his flock, or at the larger church in Northleach, where from 1761 onwards the Bishop of Gloucester himself exercised the advowson. But in all the official records, under the heading "Charities for the Poor", there is for both Hampnett and Northleach the stark entry "none known".

So Daring Dick's contributions must have been most discreetly distributed to his beneficiaries, and while the perhaps slightly conflicted churchmen involved would have been in little doubt as to the provenance of all this

bounty, they probably found it easier to play their essential part in this early manifestation of socialism by sticking to the age-old maxim of "ask no questions". Which probably explains why, as far as the Church was concerned, this was all kept strictly "off balance-sheet".

Daring Dick Dreadfus was never caught, and his "collaboration" with the seductive Lady de Kuyper only came to light several generations after their deaths. Dick was said to have had mistresses in Stow, Burford, Cirencester, and even in Northleach itself, plus a string of more casual "admirers" in most of the villages in between, which between them all would have provided him with an almost infinite choice of "safe houses" in which to lie low during the hue and cry that followed his more audacious or high-profile robberies.

He was held (by those who saw him unmasked) to be a "devilish handsome fellowe" with fair hair and piercing blue eyes, and that he was both charming and debonair there can be little doubt. Even in his declining years he was noted by one of the great beauties of the day to be "the verrye epitome of eternal youthe". What is certain is that he was fearless in the pursuit of both women and treasure, and very widely admired on both counts. Had he lived in the twentieth century he would probably have been a damned good cook as well!

THE SLAUGHTERS *Or*

A TALE OF TWO SLAUGHTERS

Two of the most picturesque villages in the Cotswolds are Upper & Lower Slaughter.

Both boast superb Manor House hotels, the Lords of the Manor in Upper Slaughter being a member of the prestigious Relais & Châteaux association; and the annual riverside fête in that village, usually held around the second weekend in July, is one of the most successful and well-patronised in the region.

These villages are bucolic idylls, Upper Slaughter being memorably described by one of its most prominent retired American residents as "a sort of rural Brigadoon".

Visitors are always intrigued by their name. How, or rather why, were they called The Slaughters? They lie nestling in the Wolds just to the west of Stow, and if you visit the tourist information centre there you will be handed a sheet of paper on which it says that "slaughter" derives from the anglo-saxon word "slohtre" which, they say, literally means a "muddy place". Better then, perhaps, to live in Upper Muddy Place than in Lower Muddy Place!

And yet if one asks an English scholar, who will have studied Middle English and Anglo-Saxon, he will assure you that the modern word "slaughter" has its origins in words that do distinctly imply massacre, and that indeed is what seems to have occurred.

One has again to troll back through history and examine all the usual suspects where rape & pillage were concerned, and, as ever, one comes up against the Vikings, a society whose very watchword was pillage. They began their infamous European raids towards the end of the ninth century, and they really got about. In the 850s they founded both Kiev and Novgorod; by

the first millennium they had reached America. In between, they discovered Iceland and they colonized north and east England. In 878 Danelaw was, no doubt reluctantly, accepted by King Alfred.

This made them virtually England's earliest tax collectors, and certainly the most efficacious. That is to say, they practiced a form of national extortion, and the tithes they imposed were known as Danegeld, or Dane Gold. The sanctions for non-compliance were simple and straightforward – indeed, the envy of today's taxmen. You either paid up, or you died. No half measures, no time wasted on appeals, no discounts or allowances. If a whole village resisted, it was burned down, with a spot of preliminary rape & pillage thrown in for good measure. Rather like the Third Reich and Stalin's Russia, where in both cases crime was at its lowest level in history because if you got caught you got shot, it worked. Politically incorrect if you will, but about 99.9% effective.

Except in Upper & Lower Slohtre. Danelaw on the whole applied well to the east, in what today are Lincolnshire and East Anglia, but occasionally raiding parties would forage further west, sometimes settling, and wherever they went they claimed their tribute in Danegeld, usually getting their way on the age-old principle, to adapt the phrase, that it's actually better to be red than dead.

However, when the blond giants in their horned tin hats arrived one September day in Upper Muddy Place and gave the elders of that ancient settlement just 24 hours in which to assemble their wealth and hand it over, they were greeted with a fundamentally uncooperative side of old Britannia (by now a mixture of Angle, Saxon, and Goth in addition to Ancient Brit), and even if they didn't perhaps understand the detail of the varying grunts, it was very clear from the sign language that they were being told to bugger off.

Not having had an excuse for a really good scrap for several months, the raiding party's eyes doubtless gleamed, and they retreated behind the wold until sunset, after which they returned, spent their Happy Hour raping and pillaging, then massacred the entire settlement and burnt the whole place to the ground.

The next day they descended to Lower Muddy Place, where to their utter glee they got the same dusty response, and by late afternoon both Slohtres were little more than a heap of dying embers. Shrugging their huge shoulders, and seeing little more to be gained in the vicinity by way of fun or profit, the Vikings moved on.

Two small hunting-parties of young men from the villages had been abroad during those dreadful days, thereby fortunately escaping the Danewrath. On their return they discovered the ruins of their homes and the charred remains of their families. They rebuilt their settlements, married girls from other villages across the Cotswolds, raised new families of their own, and then left to join the gathering army of Alfred the Great,

determined to have their revenge on the savage invaders.

They got their wish. In 878 Alfred's army defeated the Danes; and the two villages were re-named The Slaughters in memory of their butchered populations; and it is said that on September nights when the wind blows from the east, few will venture into the fields between Upper & Lower Slaughter for fear of the strange noises and the unquiet forms that flit among the trees before the dawn.

BOURTON-ON-THE-WATER

The Japanese Connection

Bourton-on-the-Water may well justifiably be described as the Cotswolds' ultimate tourist destination, thanks to the broad greensward that adjoins the river for the length of the village with its museums, its souvenir shops, and its tea rooms. Its "season" begins in the Spring with glorious displays of daffodils and ends in the mists of late Autumn, while in High Summer it is sometimes hard to see the grass for the heaving crowds of travellers from every corner of the globe, with a notably high level of representation from what used to be known as the Empire of the Rising Sun.

What these very welcome visitors from the islands of Honshu, Hokkaido, Shikoku, or Nyushu might not realize, however, as they discover the latter-day pleasures of this delightful village, is an amazing and almost totally unknown connection between Bourton and their own country. To appreciate the perspective of this bizarre link from a distant past, it is necessary first to situate events in Japan in relation to the history of England.

The first know ruler of Japan was Sujin in AD 230. As early Imperial power grew, the Japanese invaded Korea (this was to become something of a habit) where their sway ended effectively in 562 (and in 663 they finally withdrew altogether). By the end of the first millennium the country was wracked by civil wars, following which the Fujiwara clan held power for a century, followed by the Kamakura reign from 1185 to 1333. A samurai family, the Taira, had in 1160 gained control of the government but in 1185 they were overthrown by their rivals, the Minamoto. In 1192 Minamoto Yoritomo established the first shogunate, usurping the power not only of his rival samurai

families but of the Emperor himself. These shogunates, or military governorships, ruled the country thereafter until 1868.

In 1219 the Hojo clan replaced the Minamoto family, to be overthrown just over a hundred years later, in 1333, by Daigo II; he lasted only three years until he was pushed out by the Ashikaga family. More civil war followed, and lasted well over a hundred years until finally, in the very late 1500s, Hideyoshi destroyed the feudal lords' power and unified the country. Korea (again!) was his undoing: he invaded it twice, and met his death there on the second campaign in 1598.

The Tokugawa shogunate was then established. In the 1600s the West, most notably the Dutch, began to trade with Japan, but this was not a good time to be a European Christian missionary in that country: missionary execution levels reached their height in 1622/4, and in 1638, fearing the destructive influence of foreigners on their ancient culture, the Japanese passed a series of decrees that closed their country to all outsiders.

Only in 1854 did Commodore Matthew Calbraith Perry, an American naval officer and distant ancestor of the great Oxfordshire inventor and luminary, Jim Perry, compel the country to open its ports for trade with the still-young U.S.A. First arriving in his black paddlesteam warship on the 8th July 1853, accompanied by two huge jet-black coal-burning warships towing two sloops, he astonished and terrified the townsfolk of Uraga on the outskirts of Edo, the vast capital of feudal Japan, as he and his menacing fleet entered what is now Tokyo Bay. His hi-tech descendant Jim would relish the thought that this was The Empire of the Rising Sun's very first contact with the products of industrialization! And it is interesting to note that even then American might was making itself felt.

Then in 1868 the almost 300-year Tokugawa shogunate ended with the Meiji Restoration which continued to 1912, during which time Japan and China fought over Korea in the war of 1894/5, Japan then gaining Formosa, today's Taiwan. The rest most people know.

Britain and Japan are both maritime nations and both have evinced a certain addiction to empires, as well as to trade. This has created a mutual respect, albeit severely troubled & tested by the events of the mid-20th century, and also to a long tradition of often discreet contact, mostly of a mercantile nature. Over the centuries this has involved the dispatch of emissaries, frequently clandestine, whose names have not always figured in the history books.

These contacts really began in earnest in the reign of Elizabeth the First. Her high-profile sailors (Drake, Raleigh, Sydney) ranged the western oceans committing acts of blatant piracy in her name, while on the other side of the world Hideyoshi's mariners were on a similar oceanic "qui vive", as any Korean at the time would attest.

What is less well-known is that there were exchanges, that English ships sailed east to rendezvous with Japanese ships, and when they met they swapped emissaries whose task it was to visit the other's country and learn its ways and indeed to absorb the latest of its technology.

One of these early Imperial representatives was Hideo Kadawaki, the brother-in-law of Hideyoshi's young cousin Hoko, he who would later become a provincial governor under the shogunate of Tokugawa Ieyasu after his succession in 1603.

Hideo was just the first of many generations of Kadawakis to visit Britain, and because of the secret nature of his mission Good Queen Bess decreed that a

discreet house should be put at his disposal in the west, two days' coach ride from the capital, in a charming riverside village that today is again visited by many Japanese tourists, namely Bourton-on-the-Water. Here His Excellency Kadawaki-san received visitors from all over the country, and amassed a collection of English gadgets and utensils that he took back to Japan at the end of his visit. It is said that he spent many happy weeks walking by the river or along the banks of the lakes outside the little town, and that while he was there he composed a Book of a Hundred Haikus, all dedicated to the exquisite countryside he discovered in the region as he explored it on foot and on horseback.

What the villagers must have made of this exotic guest in their midst we can only conjecture, but his descendants returned from time to time over the centuries, visits that were only interrupted in the period in which Japan was closed to all foreign contacts shortly after Hideo Kadawaki's death as a revered old man in the early 1630s.

By the sheerest of coincidences the author found himself at New College, Oxford, in 1960 on the adjoining staircase to a Hideo Kadawaki, an umpteenth descendant of the great traveller. He too became enamoured of the Cotswold countryside and on one memorable occasion composed a haiku that he wrote (or rather painted) in giant script on one of the walls of my rooms. At the time I felt very honoured, and was fascinated to learn, bit by bit over the vintage college port, of his remote ancestor's adventures in our land. He was a very formal and a very charming young man, every bit the natural diplomat, and I have often wondered what became of him. Is he a professor of history now, or a captain of industry, or a politician? I may never know.

Why was Bourton chosen to provide that Elizabethan "safe house" all those years ago? Because it

was discreet, off the beaten track, certainly; but also perhaps because our own emissary to Japan had reported on the tranquil and philosophical nature of its people that so contradicted their equally warlike propensities, and on their ability for contemplation and introspection; and Bourton was rightly identified as being a place (before the Age of Tourism!) where such a spirit might find peace and make a sort of home from home in a far-off land. I would like to think that today's visitors from Japan, unwittingly following in Kadawaki-san's footsteps along the riverside or, for the more adventurous, around the lakes, can still feel something of that tranquillity despite the hordes of other tourists sharing their experience in the high season.

THE CHAINSAW MAN OF CRUDWELL

Not many people have heard of Mikhail de Rogate (or Mikovich, as his Russian cousins prefer to call him), known in those southernmost reaches of the Cotswolds below Cirencester and beyond even Ewen where the rolling hills at last give way to the plains that stretch down into Wiltshire, as the Chainsaw Man.

The de Rogates came to England with the Conqueror, and originally settled in the northern lea of the South Downs, where they gave their name to the eponymous village that sits athwart the cross-country road from Winchester to Haywards Heath. In time they migrated north and west, and one of their Ilk, a dynamic firebrand once memorably described by his own progenitor as an angry wasp when roused (which he was quite frequently), was young Mikhail.

No-one quite knows when he discovered the joys of his first chainsaw, but once he realized that it was an instrument that could do the work of ten axes and a hundred hand-held saws, his ambition to reduce all growing wood to logs and sawdust knew no bounds. Wherever he took up residence, the trees fell like leaves in Autumn; it was said that entire forests quivered when he rode by them in his gigantic Jeep, his equipment rattling in its capacious boot (or trunk, as they say where jeeps come from), and in a matter of but a few short years Mikhail de Rogate simply became known from the Bristol Channel to the Marlborough Downs, and from Malmesbury to the Wold upon which sits Stow, as Chainsaw Man.

His house, once covered in gnarled climbers and ramblers and exuding the fragrant summer essence of Olde England, was quickly given a horticultural crew-cut, the foliage on its ancient walls reduced to stubble, just as the charming old tree in its garden became an instant stump on which Chainsaw Man

would sit and tell his tales of arborial carnage as he quaffed his flagon of wine while the sun set beyond his razed hedgerows.

When not at work reducing the environment, de Rogate toured the world smashing china. This was because his hands had been so shaken by the constant throbbing of his chainsaw that whenever he picked up an interesting plate or porcelain objet d'art to examine it, as was his wont as a part of his "day job" as an international lecturer in ceramic art, he tended to drop it.

This made him especially popular in Greece, where a grateful President created him Commander of the Order of Hellenic Merit for reducing the entire Summer Exhibition of Greek pottery to smithereens, and thereby setting an unbeatable precedent for the patrons of Tavernas whose proprietors mostly owned their local potteries and who depended upon the falling levels of traditional post-prandial plate destruction for the absorption of their output and the consolidation of their profits.

His services to that lovely country's productivity made his name a byword, and as a further reward the grateful Nation, learning of his chainsaw prowess, awarded him an entire forest in Anatolia to cut down during his holidays there.

Eventually Chainsaw Man retired to a hamlet across the fields from the exotically-named Crudwell, and there he discovered his other passion which was for ditching.

Convinced that a massive tsunami would sooner or later come crashing across the north Wiltshire flatlands and inundate his bucolic retreat, he constructed dykes and dams and ditches on all sides, so that the winter waters would become protective moats and his muddy mounds would hold the torrents at bay. He knew that

Global Warming meant monsoons as well as droughts, biblical floods as well as deserts, and if his protective ditches were obstructed by roots he would wield his mighty chainsaw again, rending them and any other impedimenta (oil pipes, water pipes, underground electricity or telephone cables) asunder so the waters could flow freely, mingling on occasion with the Black Gold he had simultaneously released so they might do so. One cannot after all make even the plainest of omelettes without breaking a few eggs, he would argue, as indeed the birds that nested in the trees he felled had so often also discovered to their cost.

Mikhail de Rogate became a legend in his own time. Intensely colourful, of often trenchant opinion expressed at a finely resonating volume, he literally spanned the globe from the Americas to the Antipodes, leaving in his revered footsteps the shattered or hewn fragments that bore witness to his passage.

Whenever he returned from his expeditions, they would cheer him in the sunlit lanes of Crudwell, and hang out their flags and bunting to hide their trees. Few hedges of course remained – most now replaced by sturdy Cotswold drystone walls that even Chainsaw Man's armoury cannot reduce, for this is a community that has learned to protect itself against the living legend in its midst, knowing that at any time he might begin to hyperactivate again and chop his way across the Village Green.

WINSON

Behind the Walls

Winson is a very private village, small to the point of compactness, hidden away on a hillside far from the main Fosse Way, overlooking the River Coln.

It has a particularly fine Manor House which was built, apparently, for the Surgeon-General of the English Army around 1740, clearly a lucrative post that brought greater rewards than those of the average medical practitioner, and constructed almost certainly on the site of a far older dwelling. This would be logical, given that the church dates back to Norman times when so many village churches in the region were built for the local communities.

The Manor faces a distinctly exiguous village green, too small to interest the habitual clusters of waddling ducks that frequent the larger greenswards of so many Cotswold villages, and in the south-east corner of this patch of green there sits another rather fine mid-eighteenth century building, the gabled Fields House.

The narrow lanes through the village are lined with charming cottages, their secret gardens protected by high walls or hedges, many of which hide miniature paradises of mature fruit trees, flowering shrubs, and shaded lawns. Down across the valley lie Winson Mill and the superbly restored Mill Farm that sits back from the river under the protective lea of the far hillside.

Some remarkable characters have found their private refuges in this timeless and idyllic spot, undisturbed by prurient or prying eyes or the unwanted attentions of the outside world.

One such was the mysterious South American Generalissimo Don Moroso Ipiales Mosquito-Urbanos, known as Mu-Mu to his friends and Mozzy to his foes.

He was a keen student and ardent admirer of Napoléon Bonaparte, who like Hitler considered it was his natural entitlement to march across Europe invading and occupying other people's countries on the age-old principle that "might is right"; but unfortunately not all Mu-Mu's own campaign tactics, modelled as they were on those of his Gallic mentor, were well adapted to the mountainous Andean terrain and tropical forests of the neighbouring territories of his semi-equatorial homeland, and his stalwart efforts to achieve some local lebensraum on behalf of his half-crazed and power-mad Dictator-President were eventually rather soundly rebuffed.

Unable in such circumstances to return to base and expect to live very long on arrival, losers rarely lasting more than 48 hours under that régime, he decided rather wisely to export his genius; and thus he departed, together with a wardrobe full of very fine uniforms, to the European republic of a fellow-Generalissimo, one Francisco Franco.

There he found a welcome that exceeded his expectations, and there he prospered for a while until Spain reverted to constitutional monarchy when the already ancient Franco hung up his boots and departed for his particular Valhalla (pronounced "Hell" by the republicans who had so suffered at the hands of the Falangists); and the new democracy quickly sent Mu-Mu on his way, urging him to go north, bin the uniforms, shave the moustache, and become a banker. Which is what he did, being ever a man of the moment, and came to London.

One of his most notable characteristics was his eye for all that is best in life. In short, he was a connoisseur, albeit one with a military formation, and he possessed a keen and admiring eye for lovely ladies – a long family and indeed proud national tradition in his country of origin – as well as a similarly fine appreciation of the

better vintages of the great *cépages* of Europe.

But our naughty Generalissimo's Achilles heel, if thus it might be diplomatically and not unkindly described, was that, on the whole glorious subject of pulchritude of the female persuasion, his only concern was that it met the three essential conditions of being buxom, bodacious, and within convenient arm's reach! Which is after all no more than the practical approach of your professional soldier...more or less regardless of his *provenance.*

The fact that he was simply an enthusiastic amateur of beauty, as his exquisite taste in the Fine Arts amply demonstrated, seemed somehow to escape the comprehension of several perhaps less-extroverted Anglo-Saxon husbands, as did the field tactics that were second nature to such a military genius, involving a strictly frontal approach and, being the natural leader that he was, a very "hands-on" execution of his strategy.

And if this resulted in an occasional pop-eyed fellow-guest at fashionable dinner parties (from whom he earned his much-prized soubriquet of "Mozzy"), then

as he so rightly pointed out, the finest grapes are surely there to be squeezed rather than being left to wither on the vine – a logic and a *finesse* with which it was hard to argue, especially when so eloquently and elegantly expressed.

Was it in search of peace and serendipity that he finally forsook the Metropolis? Did he seek some sweet bucolic place where he could renew his enthusiastic studies of the Corsican Bandit's campaigns and begin the long-overdue account of his own Great (albeit sadly less than successful) Military Expeditions in the mountainous terrain of his far-off homeland? Or was it that the raucous hue and cry of the Capital was just becoming too oppressive, when all he sought was a quiet retreat from the world where he and his *inamorata* could live at blissful peace together, and he could be left to his scholarly contemplations?

It was perhaps inevitable that his search would eventually bring him to Winson, and that he would find there the perfect haven he had so long sought. It was a place where he and his English rose could saunter unrecognized of a summer's eve, unaccosted by victims (or their husbands) baying for his blood, untroubled by guerrillas seeking revenge or by journalists ever searching for a scoop. Indeed it is the last place anyone would think of looking for a refugee from so colourful a past.

And then, unknown to either of them, only a few hundred yards away, certainly less than half a mile, there dwelt Miguel Rodriguez-Cillons, scion of the great Anglo-Chilean industrial family, descended in direct line from Field-Marshal Sir Roderick Collinhouse who was seconded to command the Chilean Army in the "Conchita" Wars of 1823-29, married the beautiful daughter of the then President,

procreated prolifically, and whose descendants built most of the Andean railway systems and ended up as major South American shipowners.

Eventually, as revolution followed revolution and then finally in the last century Pinochet came to power, it was time to leave again, and Sir Roderick's great great great great great grandson found himself "back" in his illustrious ancestor's country where, as coincidence would have it, he came to live in the same village as another exotic exile from his continent. Privately, and behind high walls, in tranquillity.

And there Miguel throve. Already an accomplished artist and an enthusiastic landscape gardener, he became an industrial philanthropist, helping young and hopefully deserving enterprises to get off the ground, encouraging endeavour, and generally boosting the morale of all who had the great good fortune to know him.

His German second cousin, the Freiherr Fritz-Heinrich Wohltat von Kollinhaus, a gifted virtuoso known at the Leipzig Conservatory as the Naughty Baron, on one memorable visit once carved the family motto "Immer Zurecht" in the stone over his bedroom window at Winson, where it remains to this day, meaning "Always As It Should Be", "In Good Order", or "With Reason".

In Winson, one suspects that nothing really happens by accident; and if and when it does, it is good.

Today other great characters no doubt inhabit the village. It remains peaceful and impassive, blandly anonymous, unyielding of its privacy, a picture-postcard façade behind which there is so much yet to be told, but few prepared to tell.

MARSTON MEYSEY *and*
MEYSEY HAMPTON

There has been confusion about these villages for generations. The American railroad heiress, Meysey Marston Hampton, believed her conjoined families had their roots in both, albeit she preferred to be known as Maisie and tended to speak with a distinctly Irish-American brogue, giving more than a slight lie to her claims of Cotswold antecedence.

Certainly that most chivalrous of knights, Sir Miles de Meysey, a stalwart companion of Richard the Lionheart and a descendant of the Sir Miles who frequented the table of the Jolly Knight of Stratton, was born in the village of Marston and, some claim, added his name to it on his return from the Crusades. And his sister, the beautiful Anne de Meysey, wed Sir Eldred de Hampton, prestigious Keeper of the King's Halberds at the Court of King John, while her brother was away slaughtering Saracens.

Sir Eldred built a fine fortified manor house a league and a half from Marston and gave it his name, Hampton, to which presumably was later added that of his good gentle bride whose charitable works were marvelled at throughout the realm, in an age when giving the slightest second thought to the wellbeing of others was as rare and unusual as a two-headed hen with beakfuls of well-polished teeth.

Thus were the Meyseys present in both settlements, and thus it is presumed their name was doubly appended.

Sir Miles de Meysey was known as The Other Black Knight for his predilection for that colour, and if ever the term "immaculate in black" applied to perfection, it was to him, from the caparison of his horse to the fine silk of his doublet and hose. His armour was in

shining black, as was his helmet and even the scabbard of his trusty broadsword. His elegance was legendary (as was that of his revered ancestor), along with both the fame of his military prowess and, it was said, his wisdom accumulated from a wide experience of the world he had traversed from the green pastures of England to the arid sands of the Levant, via all the strange and varied landfalls he made along the way.

Whether these early Meyseys were the forbears of the Meyseys who later inhabited Meysey Hampton is not known. In the 13th century church there is a canopied tomb, rather ornate, that was formerly used as an Easter sepulchre and was, according to the historian Arthur Mee, "probably made for Eva, the last of the Meyseys and wife of Lord St Maur". The same church contains a monument to James Vaulx, a doctor of such reputation that the King himself, James the First, considered making him his personal physician until, in answer to a royal question, he admitted that his skills had been acquired "by practice", i.e. trial & error; and His Majesty then hastily declined to become another guinea pig! And quite a monument this doctor has, depicting him with both his wives and his sixteen offspring of all ages.

Along the road in Marston Meysey, one of the long lost features of the modern village one sees today is its once-famous Artillery Row, later to be re-named Strangenames Cottages. These formed a line of charming dwellings built after the Crimean War specifically to house returnees of the Second Division, The Cotswold Bombardiers, so very few of whom had survived the mismanagement of that lethal war and its unnecessarily heavy casualties.

These old soldiers were "characters" to a man, who, despite their general shortage of limbs in comparison to the national average, possessed a ripely merry turn of phrase to impart to any visitor to their village that they

deemed worthy of a volley or two. They are all deserving of remembrance here.

Notable among them was Colour-Sergeant Ernest Pthoth, scion of a long line of Cornish Pthoths that originated in Penzance (Pthoth being of course a purely Celtic name) who for generations had provided troopers for the Cotswold Bombardiers, ever since Ebenezer Pthoth had made his way east in search of fortune in the 1730s, only to be conscripted in Cirencester and later to so distinguish himself that he rose to become the Senior Under Officer of the regiment, indeed perhaps the most popular NCO in its long and glorious history. Ernest, or Ernie to his comrades-in-arms, was a chip off this ancient block, immobile and unflinching in the face of an advancing enemy as the megaliths of his native Cornwall, which was perhaps a mistake as Russian bullets, let alone ordnance, tended to have a more devastating effect on flesh and bones than they would have had on standing stones. Indeed Ernie counted himself fortunate to still have a right arm and a left leg, and to be able as a consequence to salute the flag as it was raised each morning on its pole at the end of Artillery Row, a ceremony that continued to the death of the last of these grand old soldiers, when it became a telegraph pole duly inscribed "The Old Flagpole". Few people today know why.

Ernie Pthoth's immediate neighbour was Lance-Corporal Hengist Snotepardon, known universally as The Forgiving Hen. He was named after his Scandinavian great-grandfather who claimed a direct descent from the Vikings, and certainly he had proven himself to be worthy of his bloodline when it came to battle. It was said in the Bombardiers that the enemy kept aiming at the wrong parts of him, because unless and until they blew off his head he would just keep returning their fire, no matter what other bits went missing, which plenty did. Some even claimed that

Kipling's famous line "If you can keep your head while all around are losing theirs" was penned with The Forgiving Hen in mind, and was thus a startlingly literal, not to say graphic, battlefield allusion rather than, as is commonly taught, a reference to a state of mental tranquility. In any event, it is true to say that almost all surviving heroes still have their heads, if sometimes very little else.

Then there was Private (or rather Bombardier) Sidney Grermes, a.k.a. Sebastopol Sid as he became known during that ill-starred campaign. His was a name that came to haunt Lord Cardigan. As a professional gunner he understood the importance of locating one's artillery on the key commanding heights. The Royal Engineers had just begun to transmit messages by electric telegraph, which was the first time this new technology had been deployed in battlefield conditions, and Sid's unit had thereby received information about the siting of the Russian guns over-looking and at the head of the infamous Valley of Death into which the ignorant and pig-headed generals were about to send their magnificent Light Brigade.

It swiftly became obvious to Sid that this would be a totally doomed manoeuvre, and while he clearly had no means of influencing the High Command, let alone even getting access to them to express his concerns, he could at least try to distract some of the Russian fire. So, having persuaded his unit and its under-officer of the merits of his plan, he guided them and their light artillery to a distant hillside from which he hoped to bombard the Russian guns, albeit they were at the very edge of feasible range.

Duly, Sebastopol Sid and his comrades opened fire, providing the unexpected diversion, just as the Light Brigade began its fateful and historic trot into the maelstrom awaiting it.

Cardigan is said to have looked up to their hilltop and inquired of his adjutant, "Begad, what the Divil's that? Are those blinkin' Ruskies firin' at themselves? Takes one's eye right off the game, demmit!"

Sadly indeed the game was soon over, and as soon as the enemy guns had decimated the Light Brigade, they turned to pick off their hilltop irritant and, as Sid later put it, "we copped an awful lot of cannon". And lost a lot of limbs in the process. But informed military opinion had it, armed with that remarkable gift of hindsight, that if Cardigan had followed Sid's instincts and provided a substantial artillery barrage from his chosen redoubt, things might have turned out very differently indeed; and when the papers picked this up and lambasted the incompetent commander, Sebastopol Sid's was a name that must have been etched upon his miserable apology for a mind forever.

Dreddie Node was another hero in this Cotswold Valhalla. Corporal Dreadnought Arthur Athelstan Node, to give him the full moniker bestowed upon him by the parent he never knew (his father was an amateur historian and rather unsuccessful lion-tamer who was eaten by one of his charges when Dreadnought was only two, his mother having died at childbirth), was brought up by his uncle Samuel Node who was himself a sergeant in the Cotswold Bombardiers. It was inevitable that he would follow him into the regiment, where as a young man barely in uniform he swiftly established himself as what was known as "promotion material".

He had been born both colour-blind and tone deaf, which had rather ruled out any thoughts of a career in the Arts, and this did create a slight problem for him in the identification of uniforms in order to know if he was shooting at friend or foe. So instead of a musket they gave him a field gun and a donkey to haul it, to the latter of which he became much attached. He thus

became part of an artillery line-up with orders to aim at the same targets as everyone else. He turned out to be a crack shot, in that he had a natural feel for distance, height, impetus, wind effect, and "natural fade". He rarely needed more than one "sighting shot" before annihilating his target, and if the spotters identified a particularly troublesome enemy position, their officers would invariably "send for Dreddie Node" to take it out.

Eventually Russian Intelligence cottoned on to this British supergun, and of course their solution was to set their snipers to work to remove the menace.

But they missed Node, and shot his donkey, thereby effectively – so they thought – immobilizing his gun. Dreddie was utterly distraught. His donkey was his friend, his comrade, his sturdy helpmeet, and the poor man was beside himself with grief. A solicitous group of Turkish troops who were bivouacked nearby kindly offered to remove the dead donkey and bury it with military honours as, they said, was their custom, and their eyes gleamed and their lips smacked when Node gratefully accepted their thoughtful offer.

For their part, they no doubt calculated that they had just acquired enough donkey kebabs to feed their entire regiment.

That night, almost blind with the pain of his loss, Dreadnought slipped into his gun's harness himself and hauled it slowly up the rocky hillside into a commanding position. He had carefully calculated the location of the snipers' nest, and so he waited for the dawn. Then, with his unerring accuracy, at the first glint of light he took careful aim, and blew the bastards to smithereens. And so his legend was established, and Dreddie Node became a part of the pantheon that comprised the heroes of Artillery Row.

Finally, there was Second lieutenant Osgood

Singlesock. The name immediately sounds American, but then one discovers that "Osgood" derives from an Early English equivalent of the Austrian "Grüss Gott", a standard greeting in Vienna to this day, that was particularly prevalent in East Anglia and sounded like "'Ow's God?", which was meant to imply "How goes it for you in the path of The Lord?"; and "Singlesock" was the collective name given to early weavers who created their hosiery out of one yarn of wool.

None of which rendered the name of Lt. Osgood Singlesock less arresting to those who heard it for the first time.

What mattered in military terms was his prowess as a gunner. His nickname among the Bombardiers soon became Singleshot Singlesock, as he rarely missed his target or required a second shot in order to reduce it to dust and rubble. Indeed his consequent economy in the consumption of ordnance made him a hero among the quartermasters whose job it was to ensure that enough munitions always remained in reserve to meet emergency needs when they arose. Even the Generals, when faced with the need to erase a particularly tricky or distant target, and especially if Dreddie Node was already otherwise engaged, would put out the word to "send for Singlesock" who would be duly hurried along the lines to deal summarily with the problem. Much-decorated and widely respected as a master of his craft, Osgood retired to the finest house on Artillery Row, and to the thanks of a grateful nation.

Pthoth, Snotepardon, Grermes, Node, and Singlesock – all heroes and names to be conjured with, the Cream of the Crimea as a noted historian of the day once wrote; and when, as old soldiers do, they finally all faded away, the Local Council changed the name of Artillery Row appropriately to Strangenames Cottages in their memory.

Sadly the cottages fell into disrepair in the last years of the nineteenth century and were demolished to make way for the very first motorized carriage repair shops in the region. When these in turn became a "garage" that eventually transferred to nearby Cirencester, the local farmer converted them back to hay barns which, by the end of the twentieth century, were seized upon by speculative developers who gleefully – and no doubt very profitably – turned them into the "bijou country residences" that they are today. I feel sure that none of their inhabitants, Londoners for the most part, would be aware of the romantic past that lurks beneath their cosy underfloor-heated weekend retreats: but then do we ever really know all that went before?

CHARLTON ABBOTS *and the*

WINCHCOMBE CONNECTION

This peaceful, hidden corner of the Cotswolds could almost personify the concept of being "locked in a time warp", so undisturbed has it been by the passage of the centuries, as timeless as the very land itself.

From its lofty hillside, Charlton Abbots gazes out across a beautiful wooded valley that can hardly have changed since a group of Knights once rode there from Camelot and one of them, Sir Tristram it is said, was so enchanted by its prospect that, when King Arthur died and the Brotherhood of the Round Table spread out across the world to fulfil their courtly mission, he settled there and built a simple dwelling on the site of what so many centuries later was to become a very fine Elizabethan Manor House, built by the Carter family in the late 1500s.

Some say that Sir Tristram's ghostly shade still haunts the spot and flits about the Manor, whose current occupant (of not dissimilar name and perhaps unwittingly a distant descendant) finds comfort in his presence and a solace in the aura of goodness with which his benign presence informs the house. Like all good ghosts, moreover, he takes great care never to carry his head under his arm when ladies are present.

It is here that that exclusively Cotswold river, the Coln, arises on Wantley Farm below Charlton Abbots, and flows south-east to join the Thames at Lechlade. There was once a hospice for lepers in the village, sponsored by the major landowners in the region, the Monks of Winchcombe Abbey, and there one of the many springs feeding the Coln bubbled up into a stone trough, producing the sweetest drinking water man ever tasted, water that eventually finds its way across the whole of England and into the North Sea; and just

nearby another clear spring arises into a round basin, but then flows the other way, to the Severn and thence to the Atlantic, placing Charlton Abbots uniquely at what the French would call "le partage des eaux", in this case a somewhat exceptional version of a watershed.

The village was linked by a Lesser Salt Way to the principal Salt Way that joined Winchcombe to Sherborne on the Windrush beyond the Fosse Way (Sherborne originally meaning "clear stream"). The wise and canny Abbots of Winchcombe, which in the Domesday Book was recorded as possessing only a few estates, launched into a major expansion programme over the next two centuries and became as a consequence the sheep magnates of the West. In the 1380s a Florentine merchant, far from home and touring the region to buy wool, estimated that Winchcombe Abbey had some 8000 sheep that earned it £350 a year, a vast sum in those days that many a nobleman could only dream of, making it the twelfth largest of all the monastic wool producers. Perhaps Good King Hal had one eye on this richesse at the time of the Dissolution...

The merchant in question, one Signor Pegolotti, is interesting in himself in that he was the ancestor of the minor Renaissance painter of that name who very often did the feet and on occasion even the elbows in certain portraits by Raphael and, allegedly, by Michaelangelo; later, towards the end of the 18th century, the family gave its name to a form of rather thick ribbon pasta on which much, much later Garibaldi once almost choked while entertaining his secret mistress, Eva-Maria Baili, during the heyday of the Risorgimento. As a consequence, pegolotti, even alla carbonara, is no longer in vogue as a staple of Italian cuisine. And finally, in the 1920s, this same family produced Teodoro Pegolotti, the bass-baritone who

sang with Caruso at La Scala before the great Enrico went to America and on to world fame. Some say Teodoro sang ever so slightly out of tune.

Close by Charlton Abbots are the remains of a more ancient past. Two Roman villas have been found, one near Wadfield Farm and another tucked away in Spoonley Wood, almost certainly hideaways for administrators and senior army officers based in Corinium, about which more elsewhere in this information-packed little volume.

But the local highlight hereabouts, the real archaeological cat's whiskers, is to be found on the edge of a wood at some 1000 feet of altitude: the famous Stone Age grave by the exotic name of Belas Knap. This name derives from the Anglo-Saxon "cnaepp", meaning simply a hilltop, and "bel", a beacon. It is an almost perfect Long Barrow, complete with its burial chambers where the tribal chiefs and other bigwigs were laid out on stone beds in caves that were literally scooped out of the walls, and it attests to the existence of an ancient community here over 5000 years ago. To stand here is to feel the wind of history, to link with a past so distant that we can only conjecture how the world might have been then. A good place to bring H.G.Wells's Time Machine, and go for a spin!

STRANGE ENCOUNTER AT
MINCHINHAMPTON

Minchinhamton is one of the most westerly villages before the edge of the Costwold Escarpment, and one of the most attractive.

Its famous Market Hall was built in 1698 as a wool trading centre, and tailors and weavers would flock to the auctions there to secure their supplies. By the eighteenth century the town had become something of a regional shopping centre, where those same clothing manufacturers would come to sell their completed garments, and where butchers, cheesemakers, dairy farmers, fruit growers, and grain merchants would all gather to sell their produce. Only the development of roads and transport in general eroded its importance, after which the Market Hall became a venue for entertainment and a place for the general conduct of municipal business.

Famous – or rather notorious – also was and indeed still is The Ragged Cot alehouse with its ghostly inhabitants, to wit its one-time landlord and all-too-often highwayman, Bill Clavers, and his wife and child who died falling down the stairs (did she fall, or was she pushed?) in a vain effort to prevent him from departing yet again one dark winter's night upon his evil business.

Less well-known is the tale of one of Minchinhampton's more courtly residents, Sir Gryndle Brimscombe-Bussage. His was an ancient lineage. It is said that he was descended from one of Offa of Mercia's most able lieutenants, known somewhat ominously as Gryn The Murderous for his multiple successes in keeping the Celtic marauders at bay; and that the family surname was much later acquired territorially, as was so often the case, through the acquisition of the lands on which the settlements of what are now Brimscombe and Bussage were first established,

including the area around Quarhouse (don't ask) and Far Thrupp (a Danish settlement?), to the north of which, and beyond Thrupp itself, is found to this day a village with the positively beatific name of The Heavens.

Come the Age of Reason the family had migrated south, and Sir Gryndle Brimscombe-Bussage had established himself in a fine house on the edge of Minchinhampton (occasionally known in verse as Mincing Hampton for reasons that are also perhaps best left unexplored), where he began to pen his incompleted and sadly now lost great work, *The Intervention*, which those that saw it at the time pronounced to be "mightily disquieting" in its allusions to some forms of Visitation from on high.

To the south-east of Minchinhampton, beyond Bubblewell and thereafter just beyond Crackstone, is a place known as the Devil's Churchyard. Perhaps significantly, in the light of those far-off events, it is on the south-west edge of some flatter land that is now the Aston Down Airfield. Many myths attach to it: that Bubblewell got its name from the cauldrons of the witches (the Devil's Handmaidens) that allegedly guarded his lair; that the Churchyard was where the Devil's disciples would come to offer, and slay, their hideous sacrifices... and further west again, just beyond the far side of today's airfield, lies Black Covert, whose darkly brooding trees, it is said, have witnessed happenings that no man should ever see.

Whether Sir Gryndle knew or even cared about these things we do not know, but certainly they would have been a strong deterrent to the simple country folk of those superstitious times to venture forth there at night, which is exactly what Sir Gryndle was in the habit of doing. Why ? Because he was a dedicated amateur astronomer, and had become convinced there were inhabited Universes in the great panoply of stars

he gazed up at through the array of primitive telescopes he would set up regularly to the east of the town on summers' or even clear winters' nights.

And then one night he recorded in his diary "a shootynge starr that seem'd to fall to earthe", quite unlike the usual burnt-out meteorites that he regularly saw streaking across the summer night sky. He carefully pinpointed the spot where it had seemed to crash, and set off at once across the fields to investigate; but when he was halfway between Bubblewell and Crackstone he saw a sight that "lefte him sore amaz'd" – a light seemed to lift off from what he had calculated to be his destination at the Devil's Churchyard, and "seem'd to soare back into the Heavens" whence it had fallen.

Hastily crossing himself, he returned home; but when day broke, he hurried out again and made his way to the Churchyard; and there he found the vegetation flattened in a broad circle, and signs of scorching in the grass. Furthermore, he noted, there were four round imprints in the ground within the scorched circle for which he had no explanation whatsoever.

Sir Gryndle Brimscombe-Bussage was known to be something of a Bon Viveur, and when he started to recount his experience to the lovely but tempestuous Jane, his bride of more than twenty Springs, she was unimpressed. Her father was the noted churchman and philosopher, Canon Tarlton Rodmarton, and he had inculcated her with the dual principles of logic and analysis. "I must believe in God," he once memorably told his somewhat bemused Bishop, "because we all know He is there. That is a Matter Spiritual. But as regards all other of Man's propositions, I require proof." So Jane's response was to say that we all know full well that nothing that falls to earth can take off again of its own volition, and that her husband must have enjoyed a Porto or two too many that evening and

had, in consequence, been "seeing things". She very strongly advised him for the sake of his own dignity not to repeat his story to anyone else.

But that was not good enough for Sir Gryndle. He didn't know what he'd seen, but he knew that he had seen it. Night after starlit night, weather permitting, he "staked out" at the Devil's Churchyard, noting from time to time unusual lights in the sky, and on each morrow systematically entering them in his Journal. And then one night, not long before dawn, by which time he had lain on his back and dozed off a dozen times, he opened an eye and looked up and saw a light in the sky above him that got bigger and brighter and brighter and that seemed to come from a huge dark object that was falling straight out of the Heavens on to the spot where he lay.

He dashed behind the nearest hedge and wrote furiously in the vellum pages of his ever-present leather-bound notebook, recording his impressions as a vast round object lowered itself slowly to earth with a soft humming sound, following which the lights beneath it were mysteriously extinguished. He even made a quick sketch of it and then, noting he would

now go and examine it at close quarters, he tucked his notebook into the hedge behind which he had hidden and set out on his mission of discovery. That is all we know.

When Sir Gryndle failed to return home the next morning, his wife went out across the fields with their servants to look for him. There was no trace, no sign of a struggle, nothing to indicate that anything untoward had occurred, though indeed he was never ever seen again – but in the top of the hedge they found his familiar little leather volume of notes; and a shepherd who had been up on the hill where Peaches Farm stands today was heard to speak of a great light that came out of the sky to the Devil's Churchyard and that shortly afterwards rose up again and disappeared among the stars.

In those days people disappeared all the time – sometimes voluntarily, sometimes not – and there was no established system to help their families find them. It was assumed that poor Sir Gryndle had been robbed and murdered, as people regularly were. He left his widow, but thereafter no heirs, so with his presumed death the Brimscombe-Bussage line died out.

Or was he perhaps later delivered back into another age, imbued with knowledge and wisdom beyond the beginnings of our comprehension? No-one will ever know.

Addendum to Minchinhampton

There are so many Hamptons in England. The most "senior" must surely be HenryVIII's Hampton Court Palace at Hampton to the west of the capital. But Hamptons are found in Devon, Kent, London, Shropshire, Wiltshire, and Worcestershire.

There's Hampton Gay (obviously a jolly place originally, but who lives there these days?), Hampton

Magma (impressive), Hampton Arden and Hampton in Arden; and then all those with a prefix.

The big boys are Southampton, Northampton, Wolverhampton, and even seaside Littlehampton. Roehampton is a suburb of London. But then there are also Beckhampton, Bishampton, Bothenhampton, Bricklehampton, Brighthampton, Brockhampton, Carhampton, Chittlehampton, Chislehampton, Comhampton, Easthampton, Felhampton, Forthampton, Galhampton, Okehampton & Monokehampton, Moorhampton, Otterhampton, Quidhampton, Rockhampton, Stubhampton (ouch!), Uphampton (?!), Walhampton, Walkhampton, Wickhampton, and Woolhampton scattered about the mostly western shires.

A few even found their way to America and are rather fashionable. Some of the prefixes have a reasonably evident meaning; others are local references, and most have a story attached to them; so there's clearly room for a Book of Hamptons for anyone who has the time and inclination to do the research & write it. But Minchin?

Well, there is one explanation, and that it that it comes from the old French word "Minchier", a chopper (of meat) into tiny pieces – hence "mincer" in English. The name would thus have had a Norman origin and infer the Hampton where mincing occurred. Or did this mean the inhabitants minced about the town with dainty, elegant footsteps? Unlikely!

Unless, of course, they were very small and walked that way naturally. Which brings one to an ancient local belief, never formally recorded, that this area received a visit from an alien race known as the Minchins. It is referenced in folklore and in local expressions such as "them be Minchins over there".

Perhaps these poor folk crash-landed and found themselves stranded and obliged to stay. One finds a distortion of this in the fairy-tale "Wizard of Oz" and the reference to Munchkins – perhaps their creator had been to Minchinhampton and heard the original mentioned by villagers. One can only speculate.

ABOUT THE AUTHOR

Nibor Raheb's ancestors came to England somewhat involuntarily at the time of the Crusades. They trace back to the great General Drahcir Raheb who was one of Saladin's most brilliant field commanders. He was captured by the Knights Templar during the Siege of Tyre in 1179, and under the terms of the truce between Baldwin IV of Jerusalem and Saladin, it was agreed that the Templars could take him and his family to Europe. They were in due course transported to England but King John, Richard the Lion Heart's regent, wanting no trouble with the Moors (sensible man), was in no mood to receive them, and they were onward-despatched to Scotland.

General Drahcir's beautiful sister Aniwde, known variously as Kniw, Sgiw, and even simply as 'De, swiftly bewitched and married the handsome Riatsala, son of the Pictish chieftain Toile'Trahkcol (pronounced in the Celtic fashion as "Eikkol"), and the two dynasties flourished in the Highland mists and along the banks of the Clyde respectively.

There they stayed for the best part of seven hundred years and a score of generations, and it was only in 1920 that the Author's grandfather, Rotciv, finally migrated to live in Mayfair together with his sons Trebor, Yddet, and Divad. Nibor, son of Divad, grew up in town & country, rather like a Range Rover, to become the clubbable, traditionalist old fart that he is. During the Soviet era he was ex-officio adviser to Sir Ambrose Prettymelon, the Minister Without Portfolio in the Shadow Cabinet of the Ukraine during its Neasden years; and once in 1963 he visited Cricklewood. Inventor of the Pnondingdram, a poly-hedronic precursor to Rubik's Cube, he was also co-inventor of the micro-electronic "reverse pressure" rasticulator that so revolutionized the postmodern

inductive theories of both Pforzheim and de Gruyt. His Cymbal Symphony in E Flat Major ("The Paddlesteamer") was performed in Yazoo City by the Mississippi State Ensemble in 1982 to critical acclaim, and later in Bald Knob, Arkansas, where it seems it was less immediately understood.

An inveterate traveller, Nibor Raheb has chronicled his many expeditions in Madhya Pradesh, crossing the dacoit-infested hills between Ahmedabad in Gujarat to Ujjain by night, and how he then descended in a pink Studebaker to Maheshwar via Dhamnod to visit his old friend Prince Rakloh of Erodni in his ancient fort. He has scaled the Himalayas (with the aid of Royal Nepalese Airlines) to chew the mountain fat with his wise old friend in Kathmandu, Itapuhsap, and his lovely wife Ahsu; he has crossed the Andes, the Sahara, and the Solent (inter alia, and in no particular order), and his boyhood memories of Strathpeffer and Cap Ferrat just after the War still bring a watery gleam to his eye.

His interest in history has always been intense – a desire to "get behind the scenes" and to find out what really went on way back in those mists of time. In that context, this little book hopefully draws back the occasional veil.............